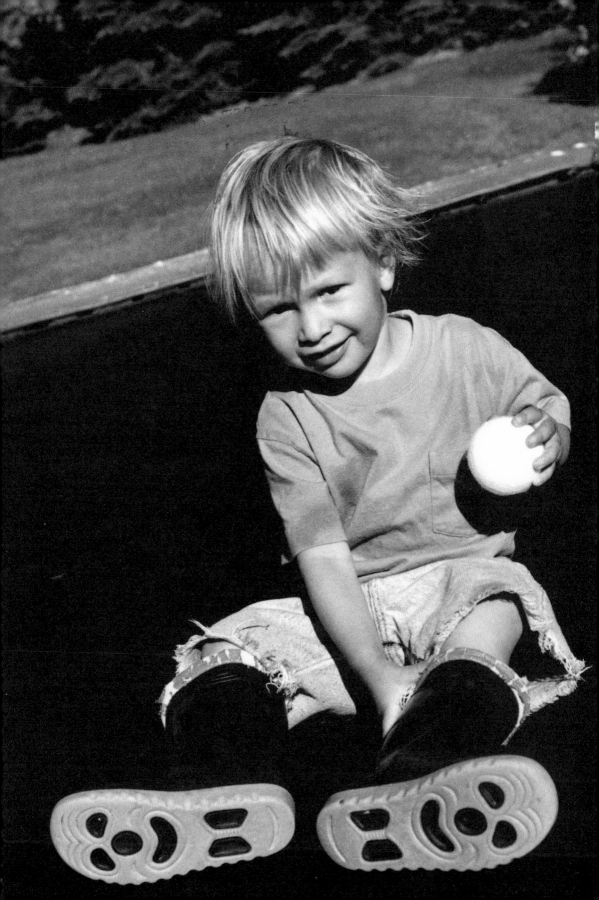

CAMERA READY

how to shoot your kids

ARTHUR ELGORT

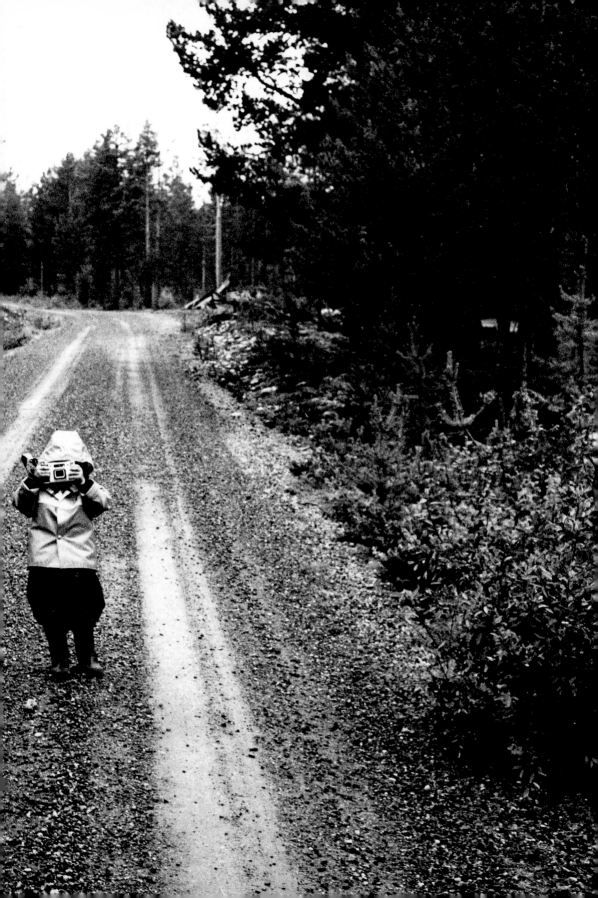

START

The first thing I'd say to someone who wants to take pictures of their kids is: *start now*.

When I married Grethe, Alexander Liberman said to me, "Marriage and having a child could be the most creative experience most people will ever have."

Before I had children, I was never known for taking pictures of them. On occasion, I would. But I never thought I was going to be an authority on the subject. Then, eleven years ago, when this creative moment finally arrived — when this child finally arrived — I found myself with an endless new subject.

Of course, in my case, I was already unafraid of cameras. I am a fanatic. Known to take a camera everywhere, except to bed and in the shower.

Now, looking back at these pictures, eleven years later, at all the personal moments I've amassed of my children, it's an amazing record. And I've realized, "This is an incredible creative outlet here. Picasso was right." So was Liberman.

Parents always take pictures of their children. My mother always took pictures of us. That's how I must have gotten into it. But she didn't leave the camera lying around the house.

So here's the difference. I'm saying, "Your parents loved to take pictures of special occasions. Go one past them. Make it just everyday life. This is your big creative opportunity — aside from creating your children." One of the main reasons for this book is to inspire people to make the most of that creative experience. To give them courage. As well as being a tribute to my own children.

NOW

Photographing my children is an ongoing part of my life. It's not over now that the book is done. I live it. And I know some good ways to get you — even if you're not a photographer — very good results. Let me take you by the hand and show you how I do what I do. Show you how it applies to what you could do.

I'll give you some advice about what kind of equipment to get. But you might already have a camera at home that belonged to your father — and you know what? — it'll work. You might just go to the drugstore and get an instant one, and if you've got the spirit, you can make that tell the story, too.

This is a book about my philosophy of taking pictures of my children. And my philosophy is not about leaving your camera in the drawer with the case on it. It's making your camera as much a part of your life as the TV or the toaster oven. It's about a few simple rules. Rules like: you have to practice with your camera, you have to take it for a walk, you have to look and be ready. It's about making photography a reflex. And it's about letting real life go on, not rearranging everyone for the camera. My philosophy is about making your own decisions: when, where, how you want to do it — it's up to you.

So start. Because they're there. And you're there. It's like your mother saying, "Practice the piano! You'll thank me for the lessons fifteen years from now." Take my advice. You'll be glad you did.

And, in the end, you may get something fantastic that a pro gets sick when he sees, because he couldn't catch the moment and you could.

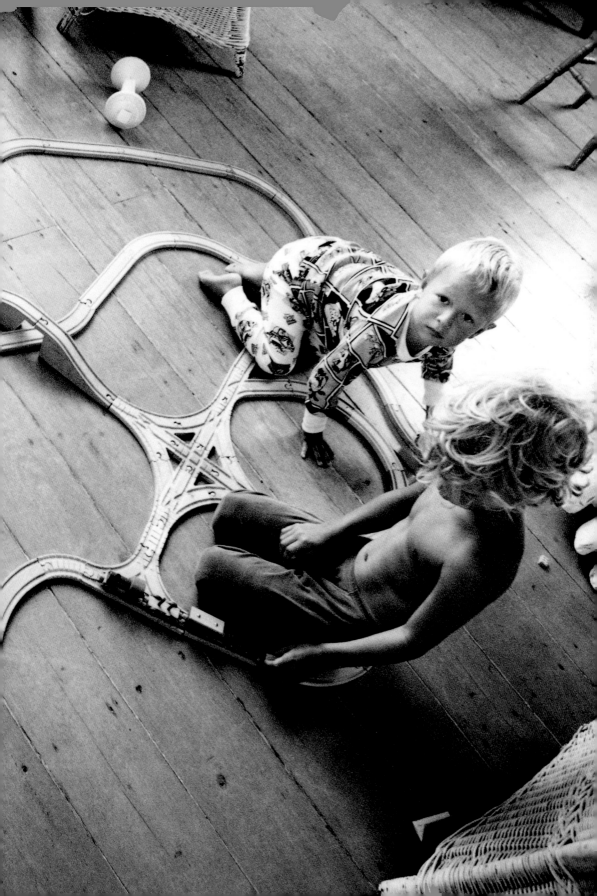

What happens is, you have a child. And if you know a photog-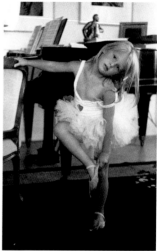
rapher, like my friends know me, you call me and say, "Every
week he's different. I want to keep a record of it. What should
I get? What should I do? What's the first step?"

Or maybe your kid is already four years old and all you
have are the school pictures and you don't like them. You're
scared to take pictures of him. Why? You may not do any bet-
ter than the school and you never looked good in pictures
either. Well, kids don't have as much vanity as we have. Yet.

Or maybe it's pride that's stopping you: what if my kids
don't come out as good as yours? Oh, it's easy for you. Your kids photograph great. Oh really? Every
parent's kids photograph great.

Or maybe you've been put off by all the camera information. Let me make it easier.

If you're a nervous person, start with a point-and-shoot. It's simple: you look through a little
hole on the side, you see something happening, you press a button thirty-six times and you bring
it to the camera store down the block. Start with that. If you have a camera, start with what you've
got, but get familiar with it. Whether simple or complex, get your children familiar with the fact
that it's just some item that sits by your side and, on occasion, you'll use it. Because otherwise, it'll
be, "Let me get my camera and read the instructions because they're doing something good now."

Practice with that for a while. Feel it. Touch it. Focus on the lamp. Focus on the cup of tea.
Focus on yourself in the mirror. Live with it. So when the real person comes in, you're not going
to be scared. Keep it in the room with you. Leave it where you can easily pick it up. Learn to see
and to anticipate. Get used to taking pictures. And process your film right away so that you can
see the results.

Next, you could graduate to an in-between camera that's modern, doesn't weigh a lot, and has
what's called a reflex and an auto-focus. Meaning, you press the button and it looks like it's focused
in, and if you press it a little harder it'll take the picture. It's particularly good for
people who get anxious.

Some people say, "I am a physical person, I like to focus."

But others will say, "Oh no. I don't want to touch anything. I just want to stick the film in at the camera store, and when I finish, I'm going to take it back there so they can take it out for me." That doesn't mean you won't come across opportunities. Good pictures happen all the time. All I'm saying is, learn to be able to shoot things. See things and get them with your camera.

Folks, I am just trying to get you into the subject. You have a choice: you could start with a point-and-shoot, but if you can cook or drive a car and you don't mind doing your homework, you can learn on any classic reflex camera with a basic F2/50mm lens. We'll get more technical later. If you have an eye and you're really into it, I might say, "The point-and-shoot is a very nice start, but you are going to outgrow it..."

The key words with any camera you choose are, "Go quiet, go light, make it easy for yourself, and practice..." I practice like a madman. I'm throwing a lot of ideas at you, but Grethe describes it very simply: "My camera doesn't weigh much. I can handle it very quickly, the shutter doesn't make a lot of noise, and the whole thing fits in my bag." That really is the premise of it all.

If you do get a reflex camera, learn how to coordinate your left hand with your right hand. Your left hand on the lens, your right hand on the shutter. Eye and Thing. Get used to looking through it. Get into it. Just like any new sport.

So here's some down-to-earth advice that I tell my friends when they call:

1) You're never too close. Get as close as you want, up to their faces. Really close.

2) Or get back. If you're always in the same spot, it's going to be boring.

3) Your sense of psychology has to play a part in it. Realize when it's not the right time to intrude. If you see it's not happening, don't force it.

4) You could practice a bit more, it won't kill you.

5) Get yourself a fast, normal lens (F2/50mm); wait until the football game for the zoom lens. Big lenses are scary for adults and children. And if you're a parent, you're probably not going to like the wide-angle lens on your children when you come in close.

6) Wait for the event where you'll need it, before you use the flash, i.e., a party.

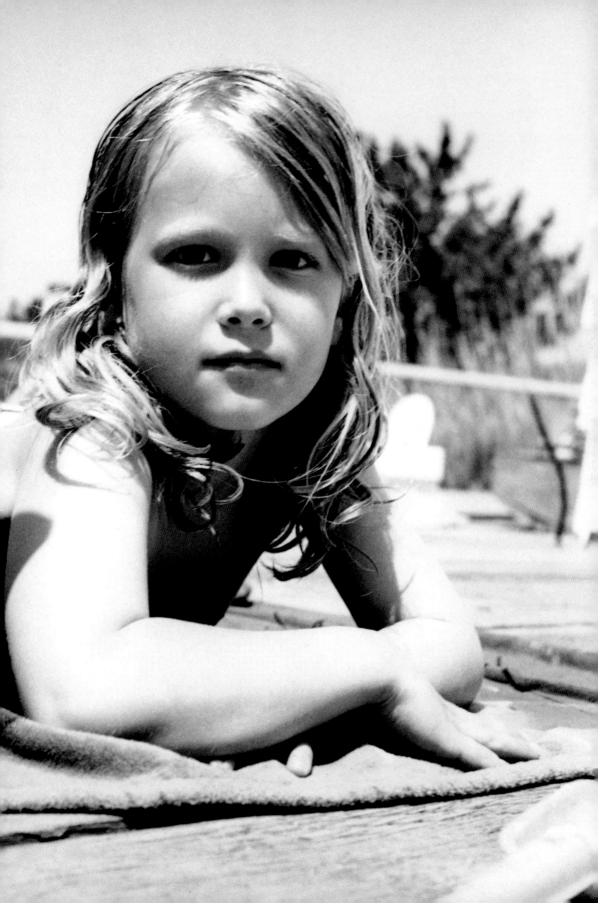

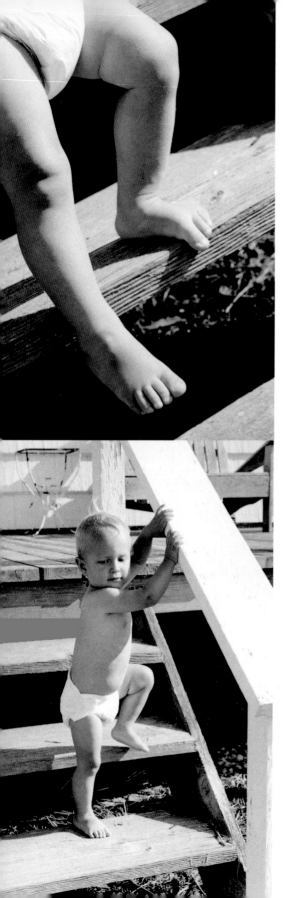

For people who are cooped up somewhere with their kids, they might find, taking pictures is not only a way to keep a record, it lets me step back from taking care of them. It's fun and it's a good way to kill time.

How can you feed a child and take a picture at the same time? You can.

For example, I'm in charge of Ansel here. Everybody's gone, except the two of us, and he's learning how to walk. It's the tentativeness of it: he's not paying attention to me. I'm just trying to make him think he's alone.

Most of my pictures are about engaging the subject. About them looking right at me. But sometimes it's interesting to be an observer and hope he doesn't fall down the steps. I'm ready to catch him. But I'm also ready to take the picture. I didn't run off to get my camera and leave him in the road.

When you take a picture, look at the details. Because the things you want to remember about children are the details.

And get down. Kneel. Sit. Get (physically) down to their level.

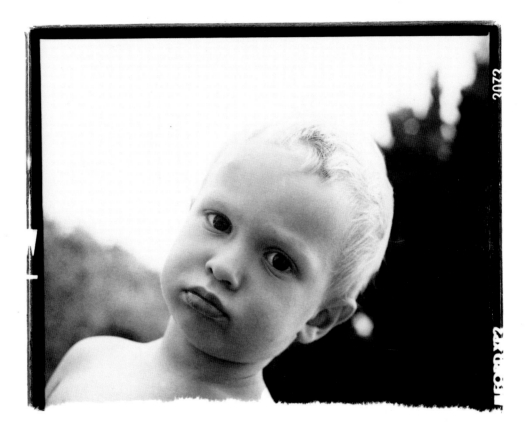

Ansel **Warren** **Sophie**

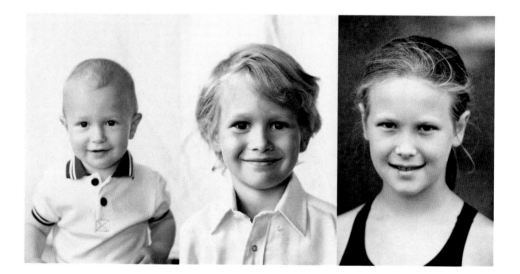

The truth of the matter is, some photographs must be done with the help of your partner.

One night, Grethe told me, "Don't forget, you have to do Ansel's passport picture before you leave tomorrow." I had to be out by 8:30, so I said, "It'll have to be 8:15."

And somehow, at 8:15, Mom had him all dressed up and ready. I used my basic camera, my normal lens and a small tripod. Then I took the reading with a real light meter. Grethe leaned some brooms against a chair and put a sheet over them, to get that backdrop the passport office likes. Grethe sat to the left and held him down. I said, "Ansel! Look at Daddy! Look at Daddy! Not Mommy, Ansel! Daddy!" And he got it. He really did. As parents, we all suffer from the genius child problem. This time, he hit it. I must have done about five shots. I remember getting them back from the lab and it was more exciting for me than getting a good picture of a model on location. Ansel is about 14 months old here. Taking their passport pictures is real history in the making. I'm proud to be their passport photographer.

S
O
P
H
I
E

Here she goes again. Sophie's the oldest. She's a do-something kind of person. She always has to have a goal: like do a somersault or swim the lake and back. She's a do-er. She kayaks, she bakes, she sings, she wins ski races. She's also a pianist. She does all sorts of amazing things.

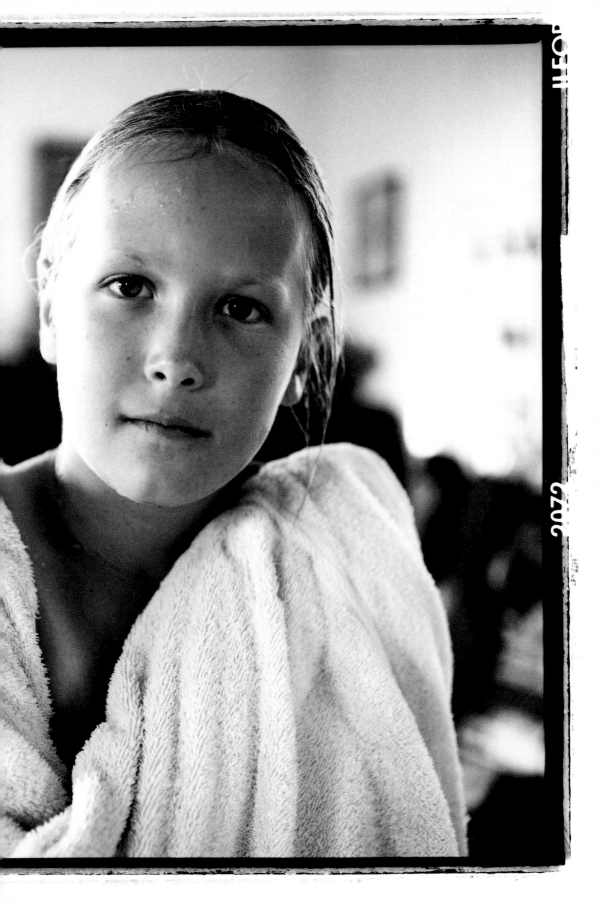

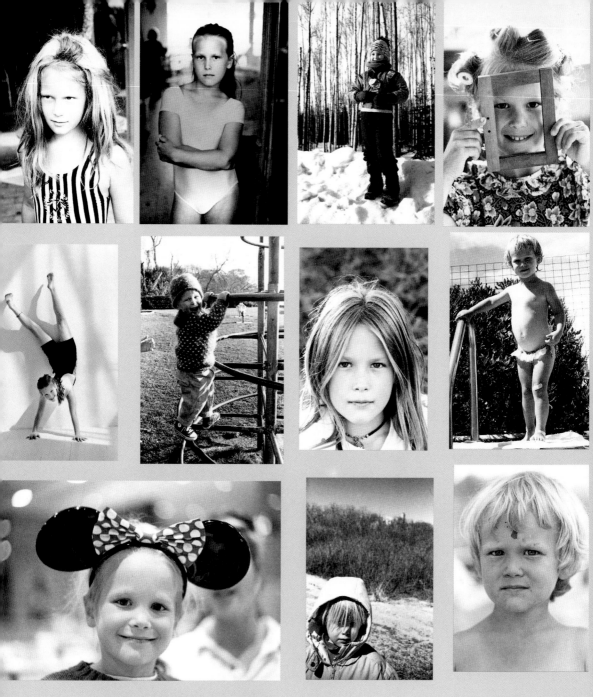
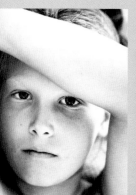
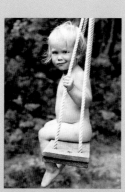
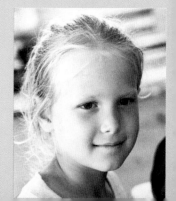

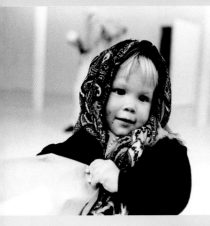
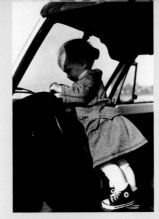
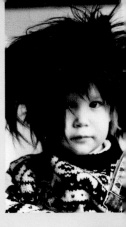
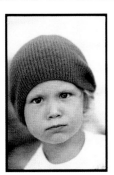
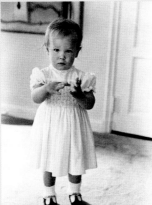
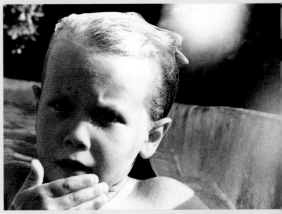
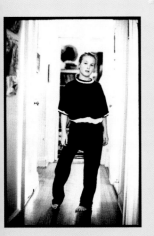
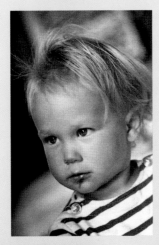
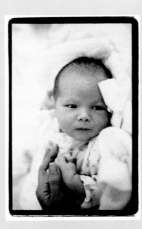
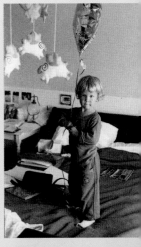
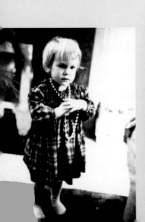
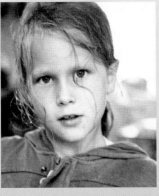
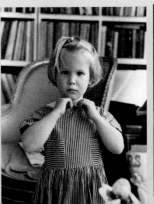
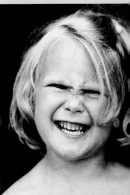

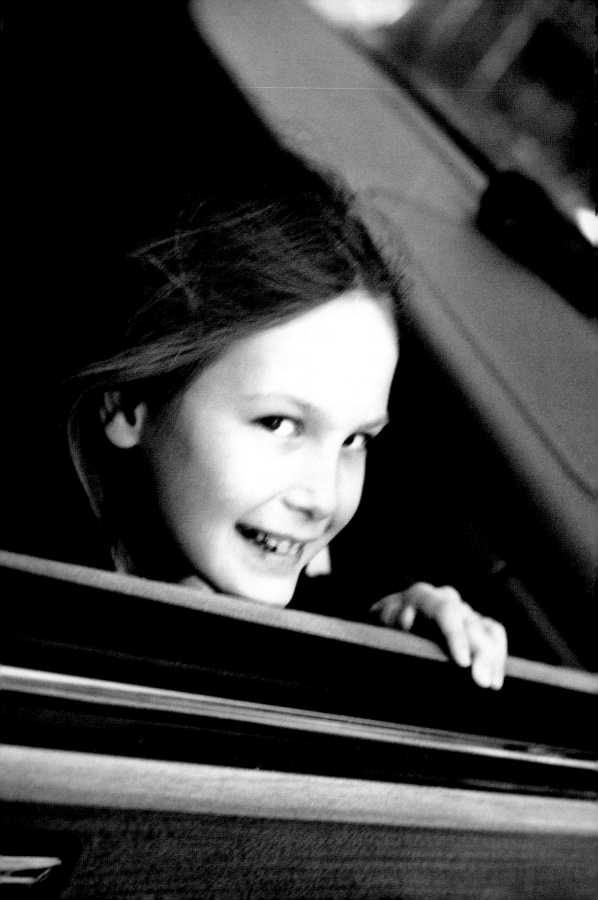

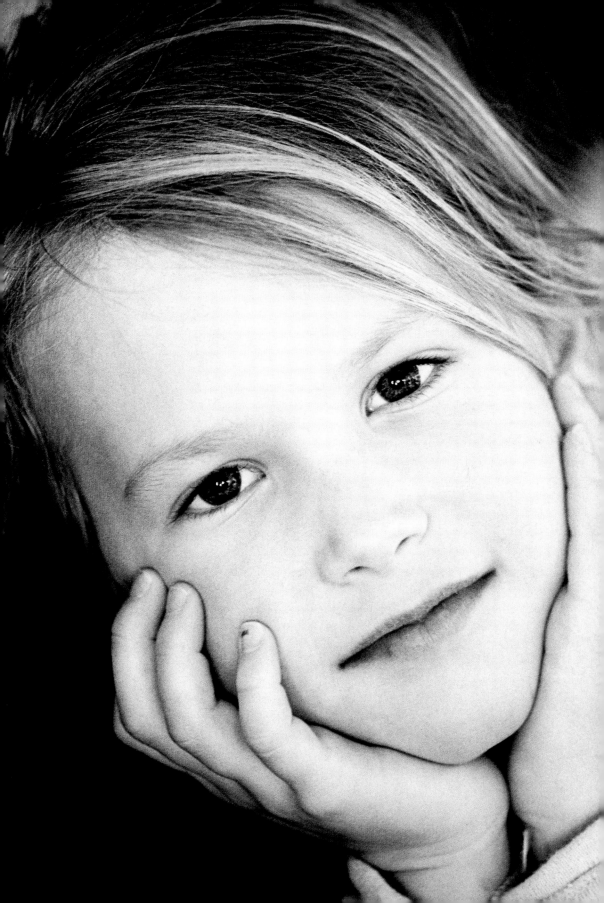

Be Prepared

Sophie stopped to tie her shoes on 85th Street and it happened to be a very good background. She sat down and I — being a photo-fanatic, wanting to get more out of it than just a delivery of my child to music school — fell to my knees and took a picture. Then she got up, I got up and we walked to music school together.

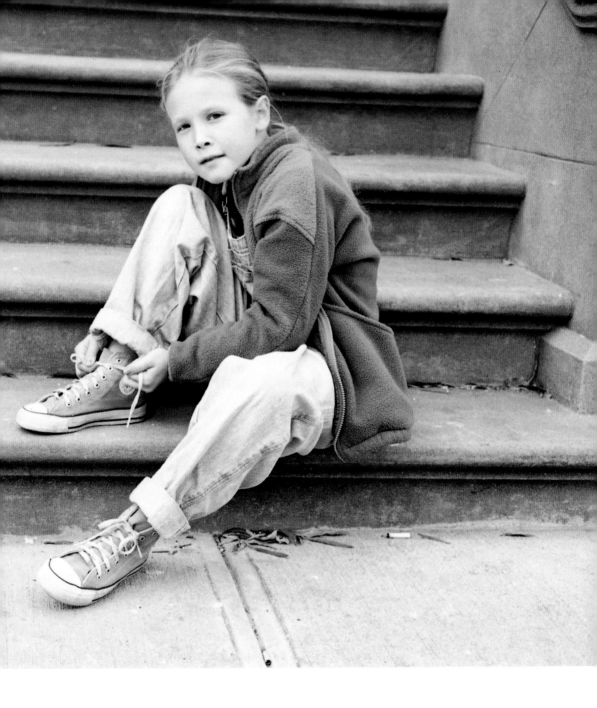

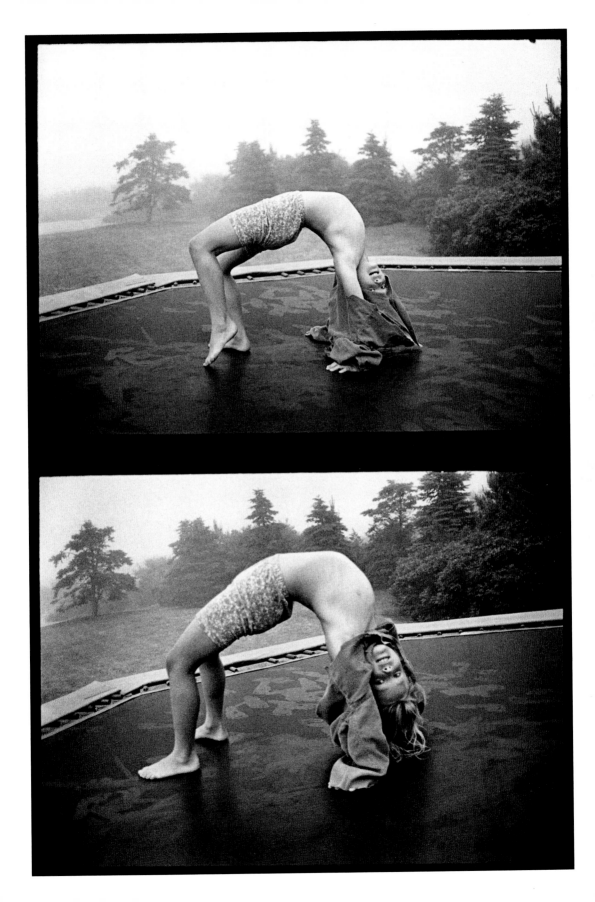

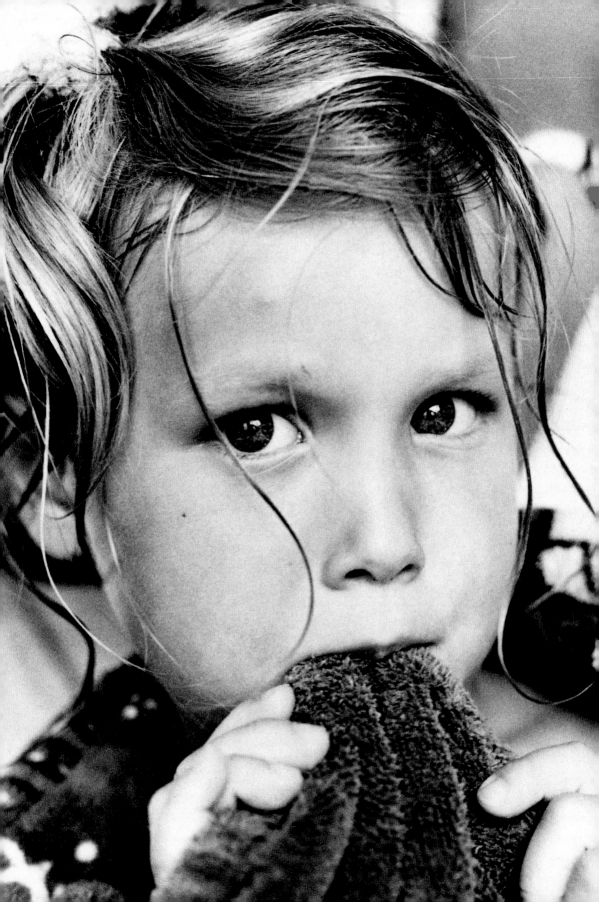

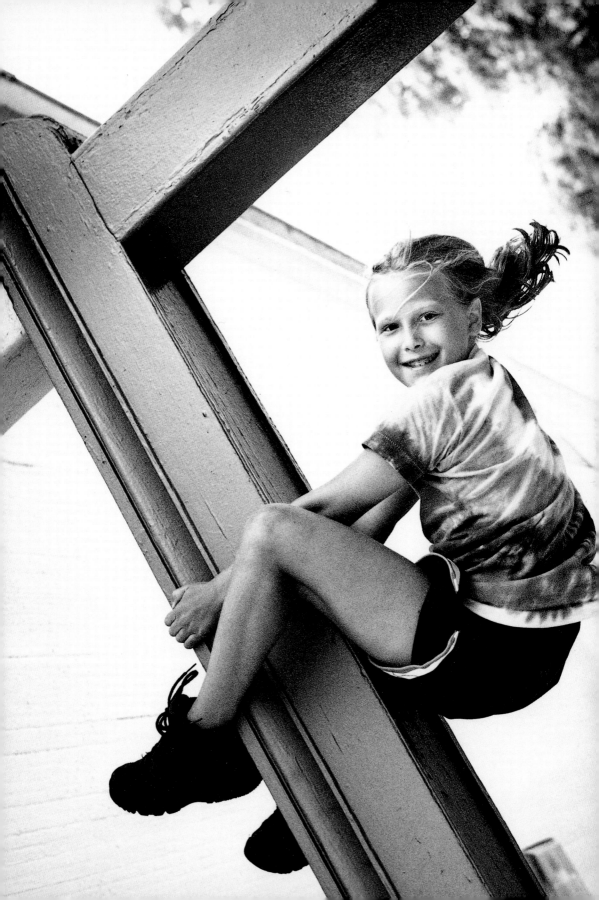

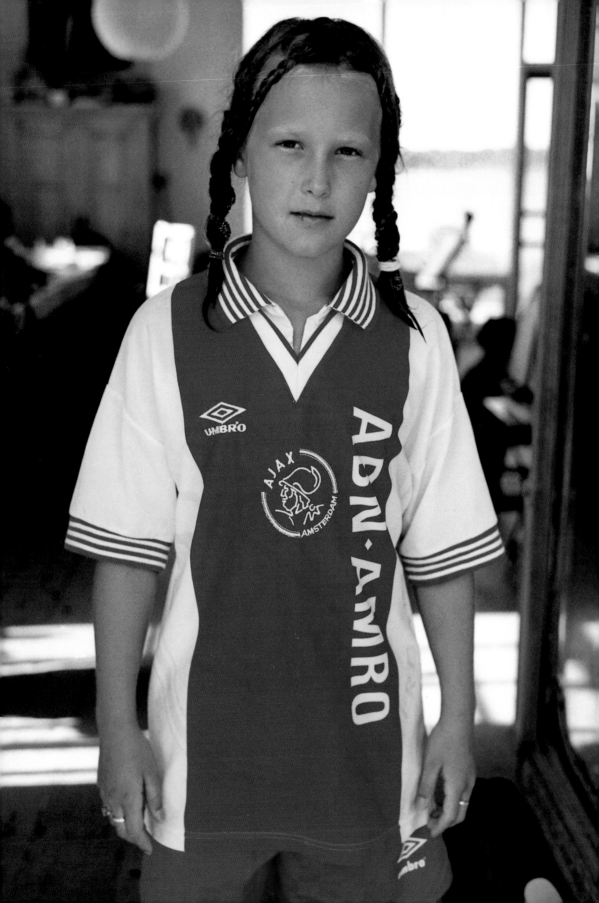

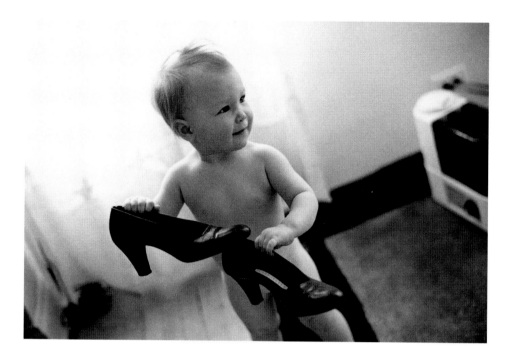

Sophie's first word was "shoes." At the age of one, she always carried them around and it was a big joke. Our first child, and she never said "Mom" first, or "Dad." No. "Shoes."

The second picture was taken a week and a half ago at a benefit. She's dressed herself for the party. Those shoes she's wearing belonged to Grethe's grandmother. And one day, Sophie noticed them. Now, as a grown-up eleven-year-old, she has annexed them, and not a word has been said.

Sophie showed up at the party and rolled her eyes about eleven times. And she walked perfectly, and she ran around in them and everything. So, for me, these pictures relate a whole story.

So if you're a parent of a little girl, you might say, it's no worse than making oatmeal or doing a few sit-ups once in a while. You just keep a camera out in the room and make friends with it. You go click, and then it's gone. And that shot could bring tears even to my eyes. And I'm a hardened professional.

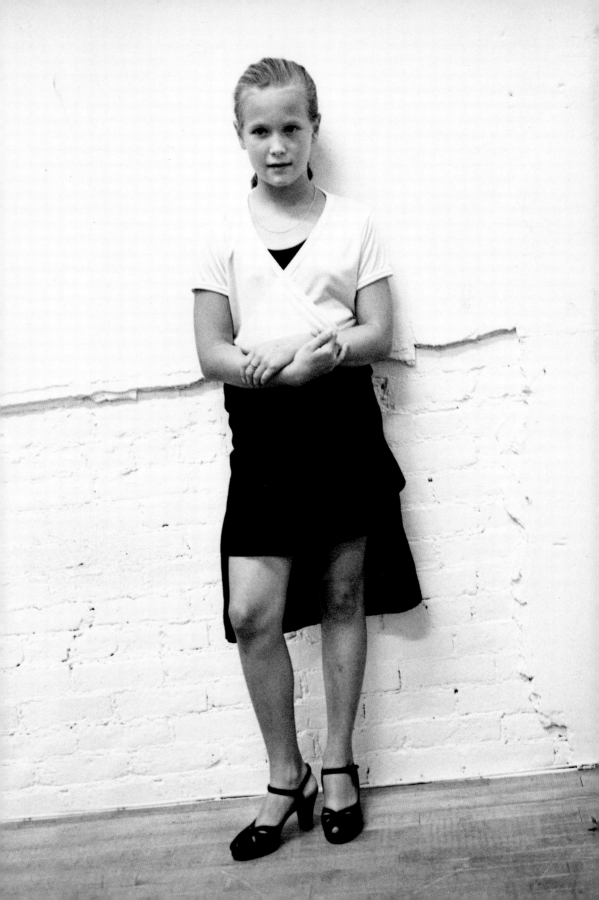

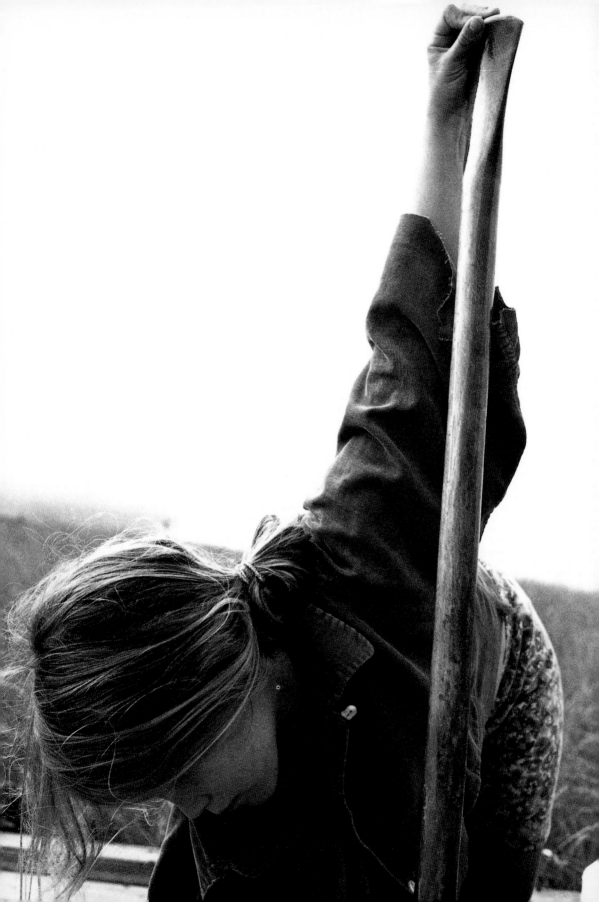

Sophie's the most self-sufficient person I know. She doesn't brag. She's very protective of herself. I'm

glad she didn't pay attention to me here.

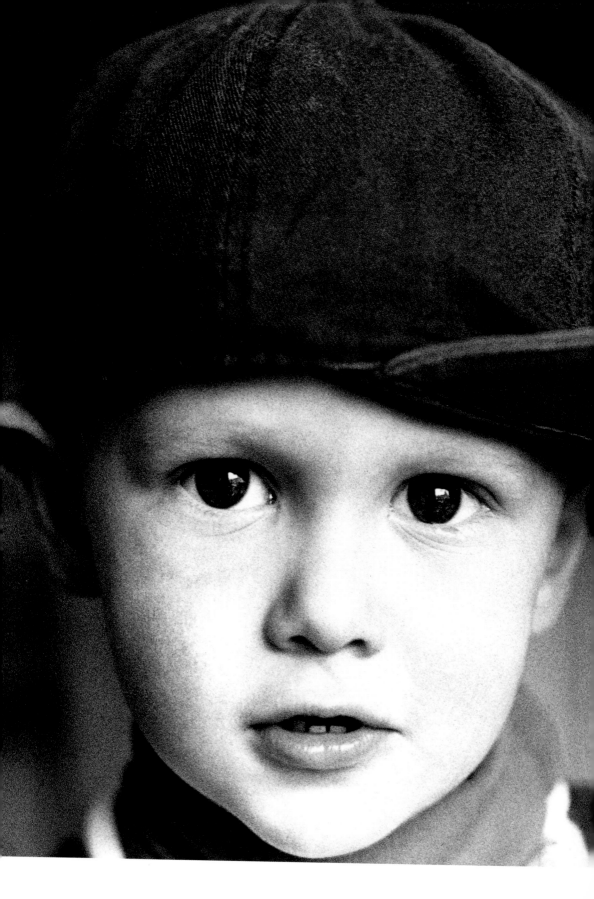

WARREN

Warren is our actor. Our future movie star. He likes to play roles. He's into soccer, karate, horses, billiards and chess. He thinks I could make more money in another line of business, like running a karate school. I should just keep the photography as a hobby.

The camera loves him.

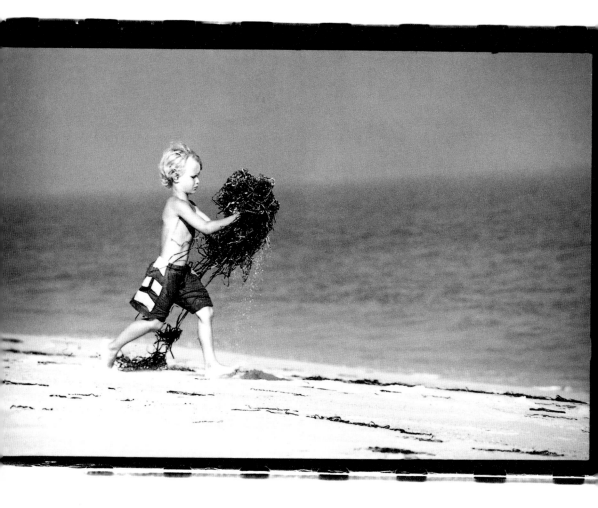

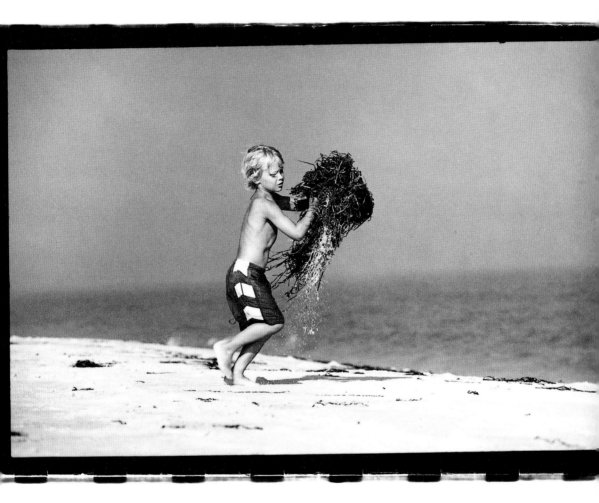

Every parent needs a zoom lens sooner or later, just don't rely on it. Here's where it comes in handy: I'm watching Ansel and Warren at the same time, while Grethe has a swim. Once in a while, I have to stay in one place and just keep my eye out. There are occasions when an observation shot can be a very strong picture. This is very much a boy unto himself.

Warren: "The best pictures are the ones I take of daddy. Daddy is better at drawing pictures."

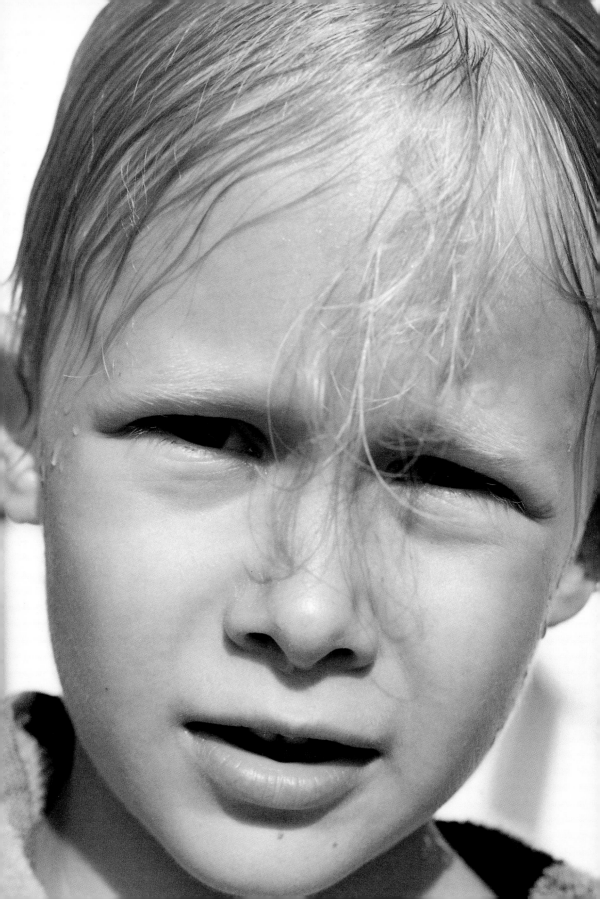

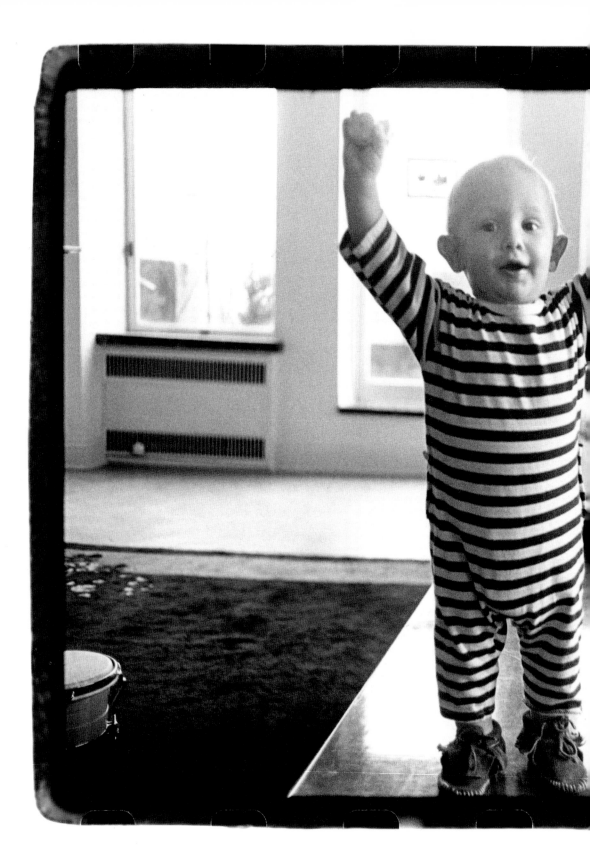

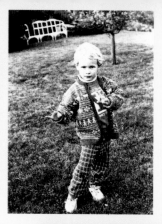
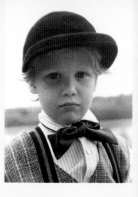
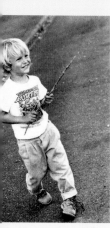
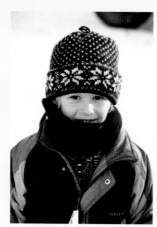
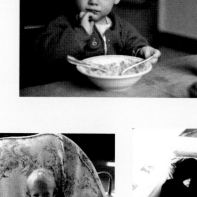
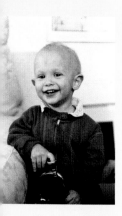
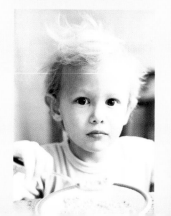

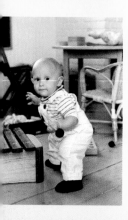
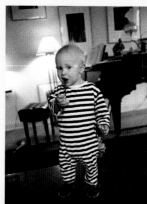
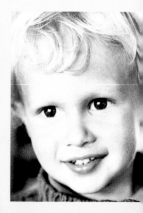

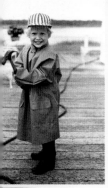
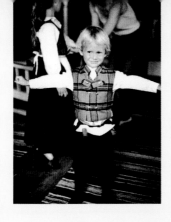
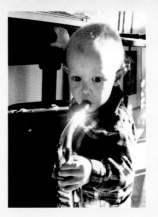
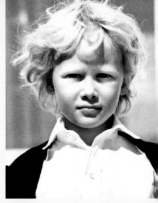
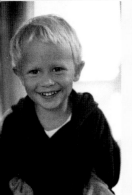
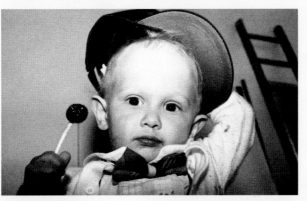
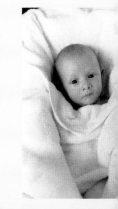
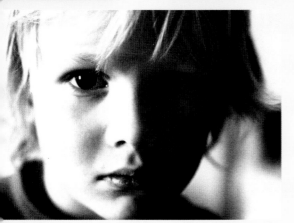
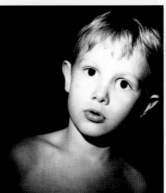
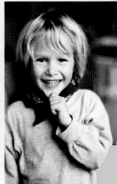
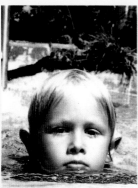
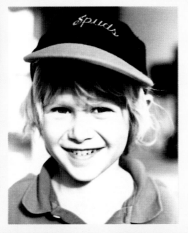
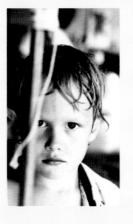
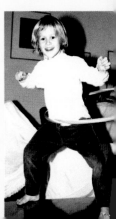

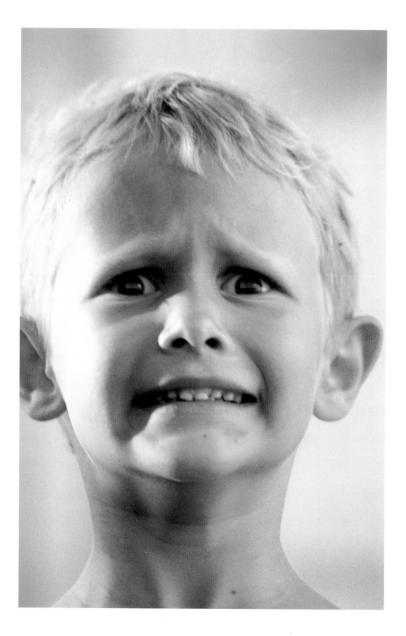

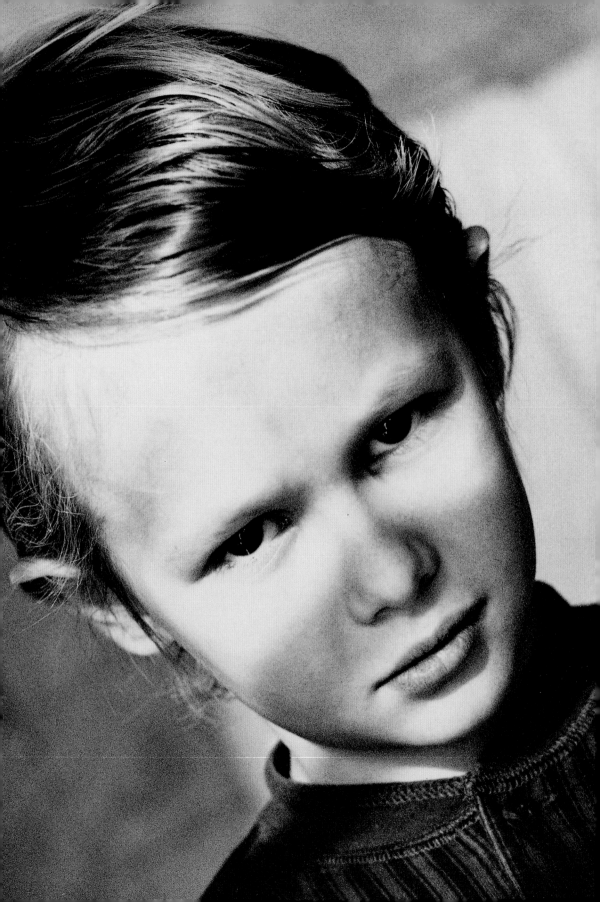

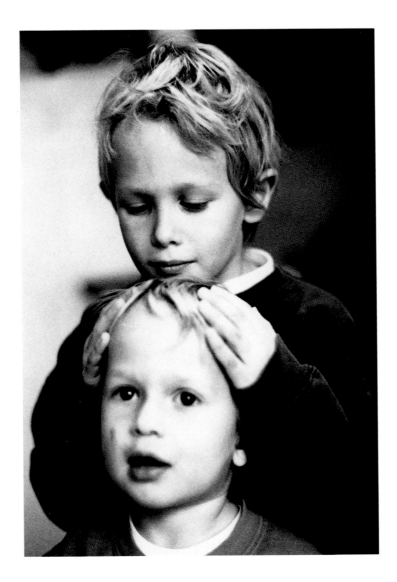

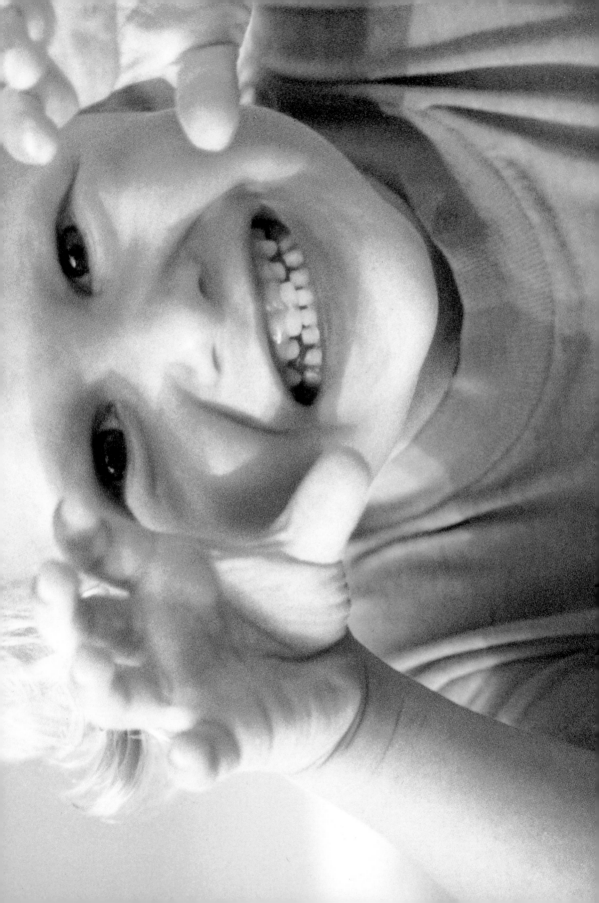

A
N
S
E
L

Ansel is the youngest and the wildest. He's a mama's boy. I don't get to spend much time alone with him because in a few minutes, he starts looking around and saying, "Where's my mommy?"

Then I say, "Ansel, you're a mama's boy, aren't you?"

He says, "Yes." And laughs at me.

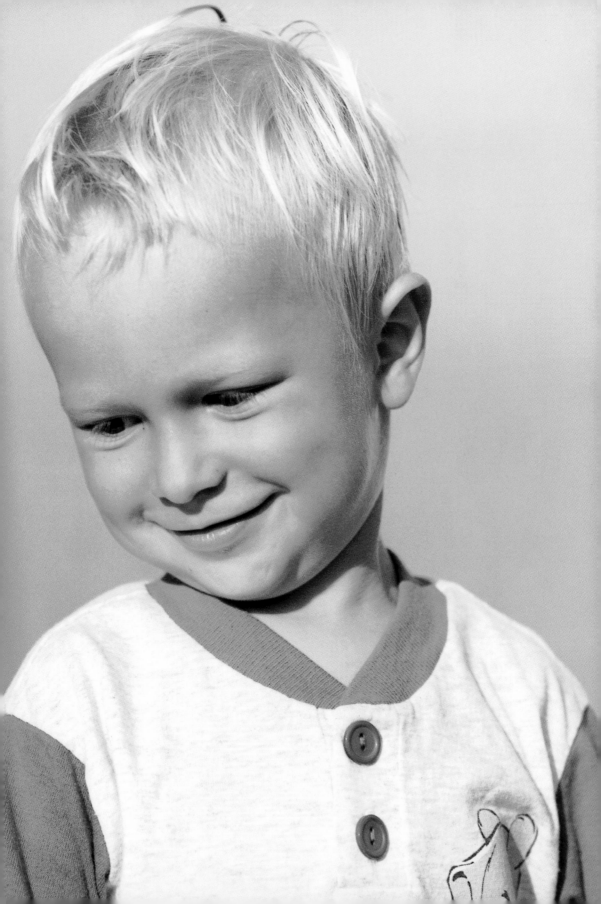

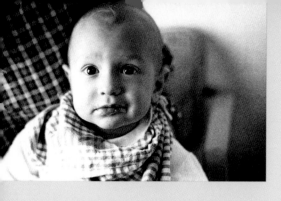
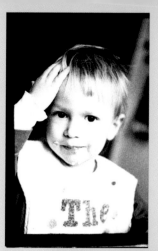
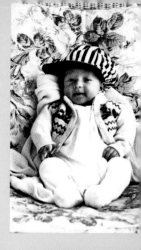
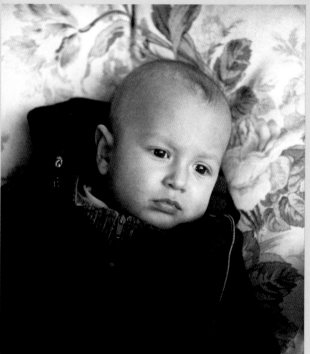
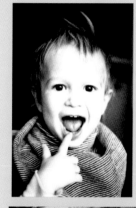
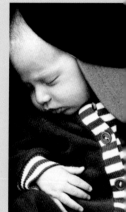
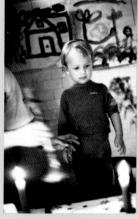
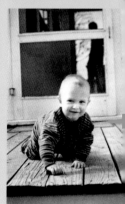
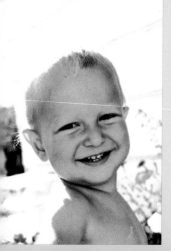
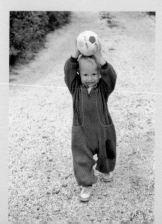
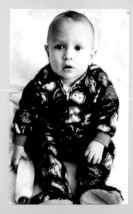
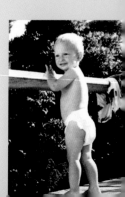

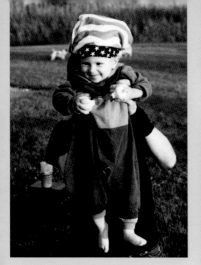
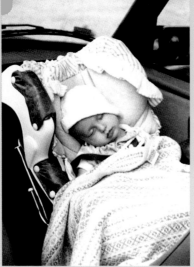
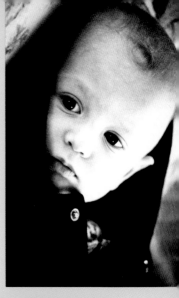
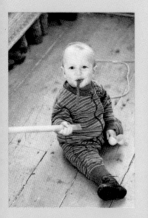
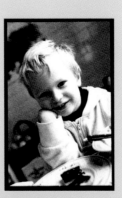
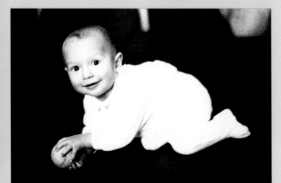
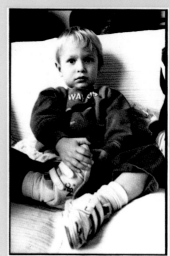
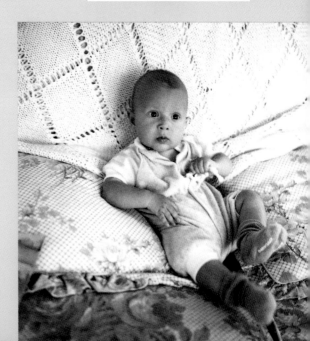
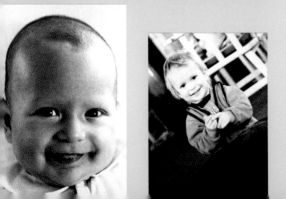

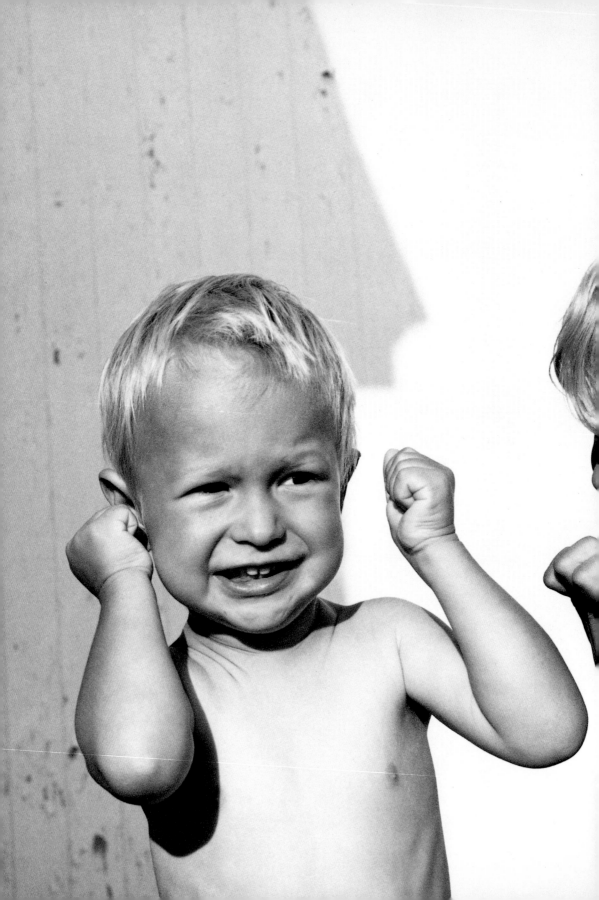

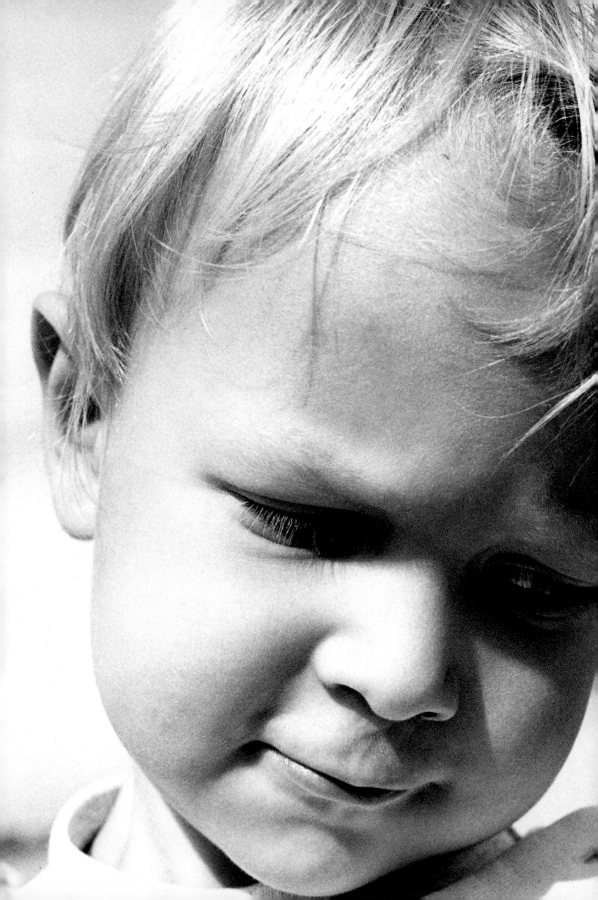

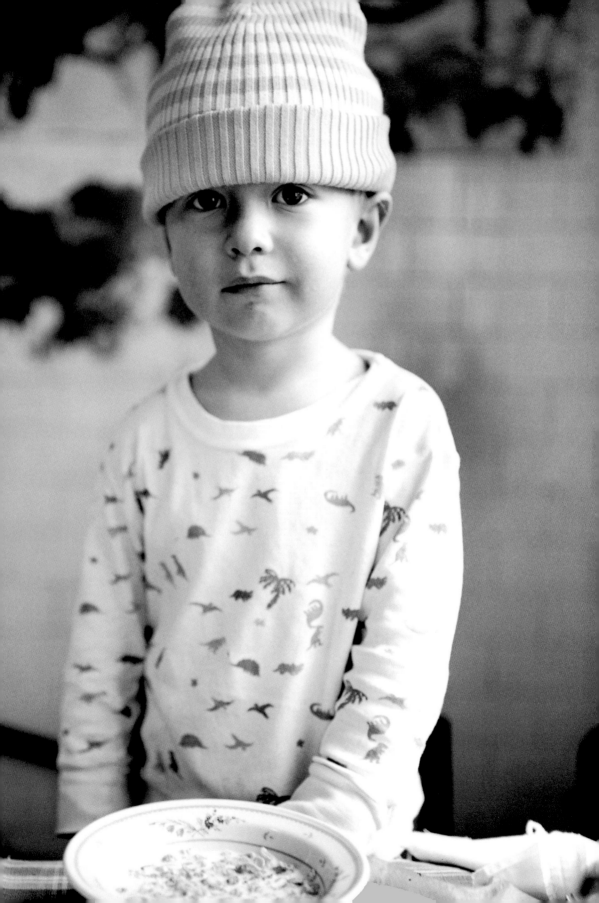

If you start photographing your kid from the time he's born, he won't even think about it. It'll be a normal thing in his life, like putting on his shoes to go outside. If suddenly, your kid is ten years old and you start snapping away, it'll be: "What's that thing in front of your face?"

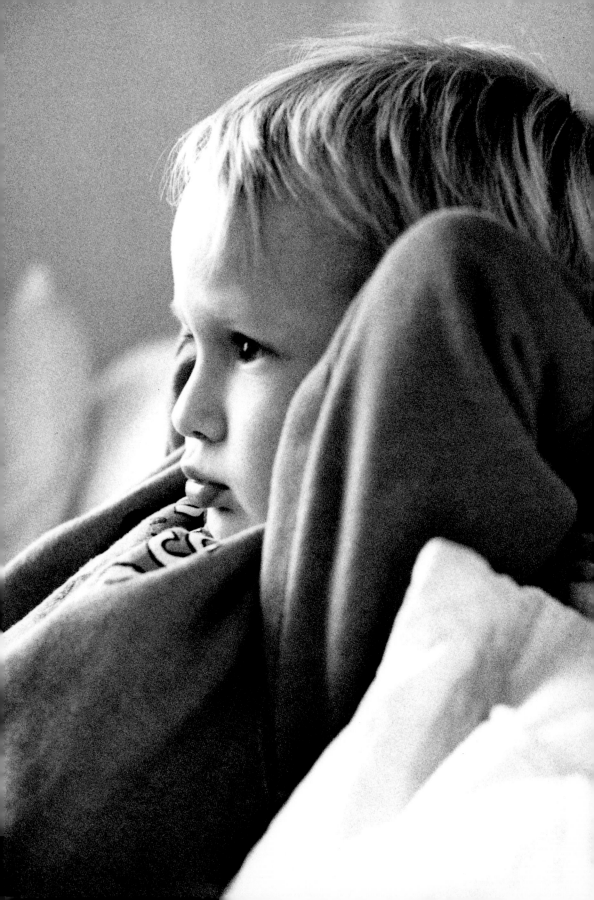

kids

look

good

in

any

light

DADDY, LOOK WHAT I BROUGHT HOME FROM SCHOOL (1/15 SECOND AT F2)

This is a very low light picture. I was shooting at a very slow speed. I just pressed the shutter and held my breath.

It was around 1/15 of a second. The longer you leave the shutter open, the more light can come in.

She didn't move and I didn't move...

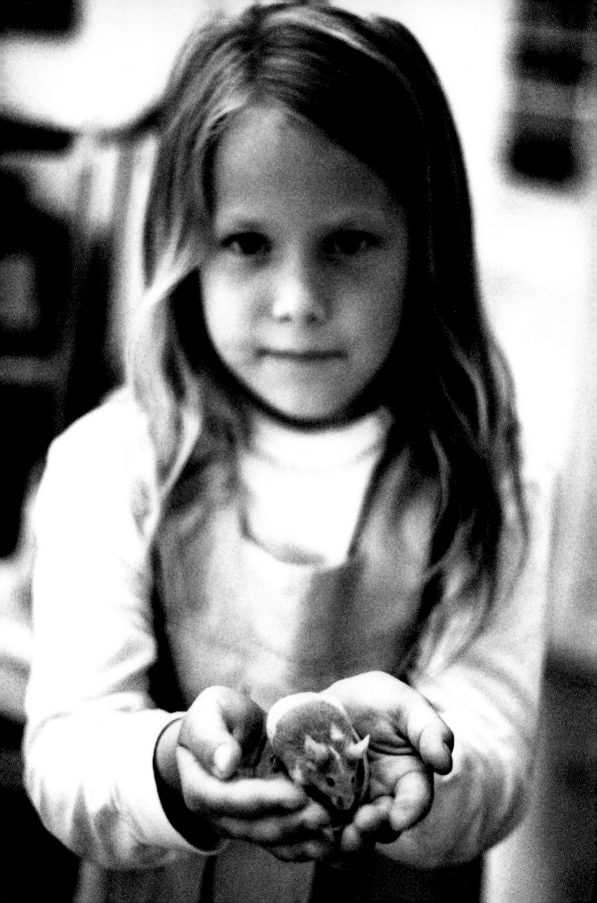

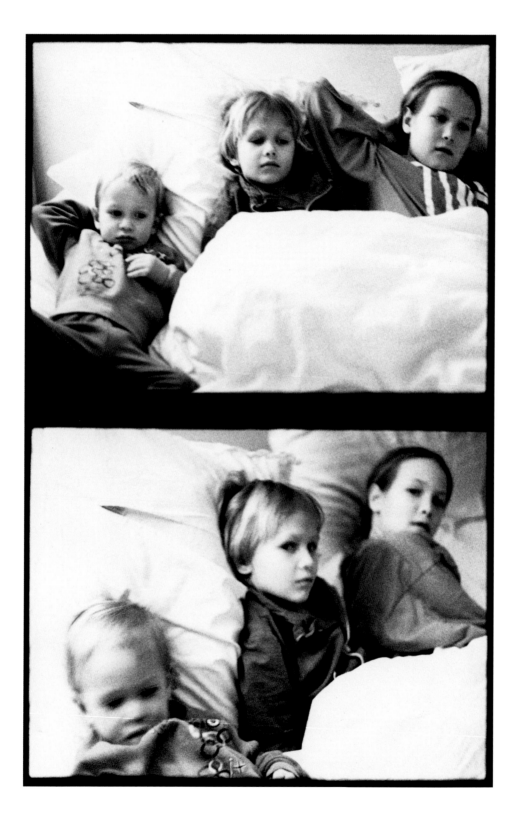

Available Light
(1/8 second at F2)

It was a dark room and they were illuminated by the TV set. I made it look like there was more light by overexposing it, using a very slow shutter speed. There was movement, but in this case, the movement worked. I would never disturb anyone by using a flash. You have to take the shot without having it ruin everybody's good time.

Some more advice for low light:

1) Just put the meter on 800 and that will help you in the dark.

2) If you do that, all you have to do is use Tri-X film and ask the photofinisher to develop it in a high-speed developer. You can go to anybody and tell them that and they're going to think you know what you're talking about.

3) I am a great believer in available light photography, that means I can make a picture in any light without a flash.

4) Don't be afraid of the dark.

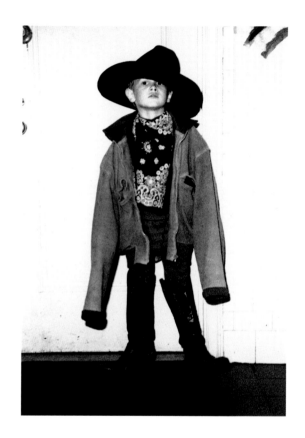

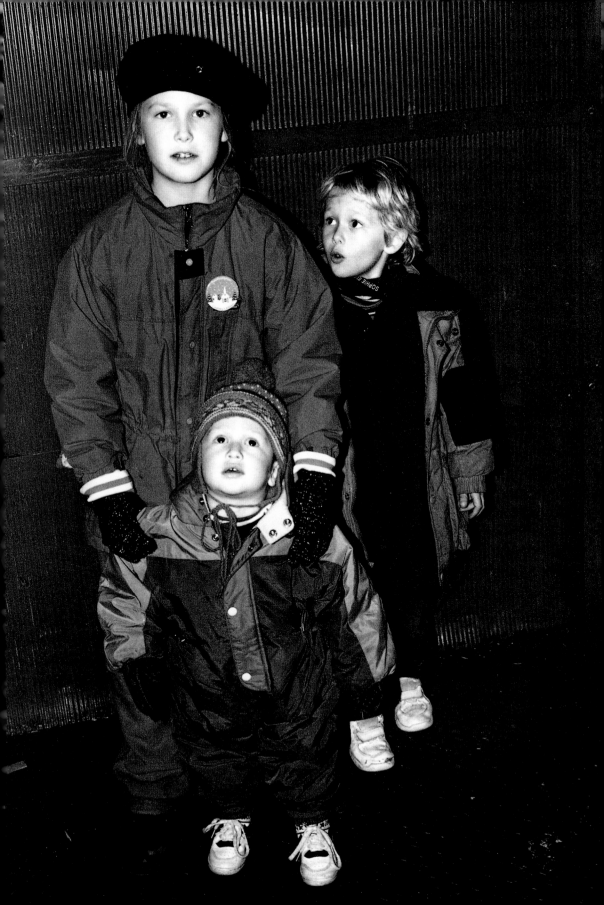

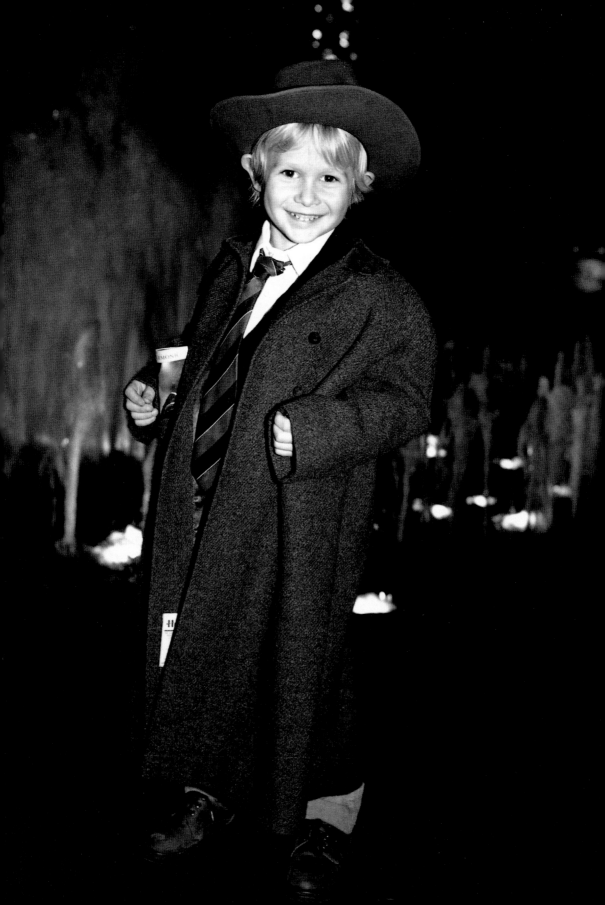

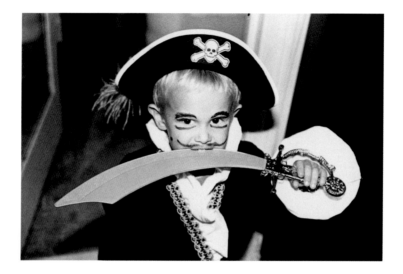

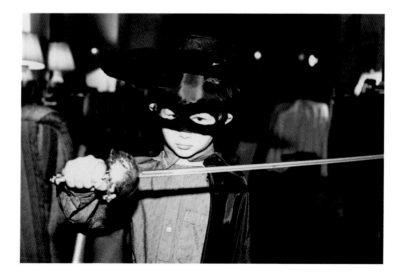

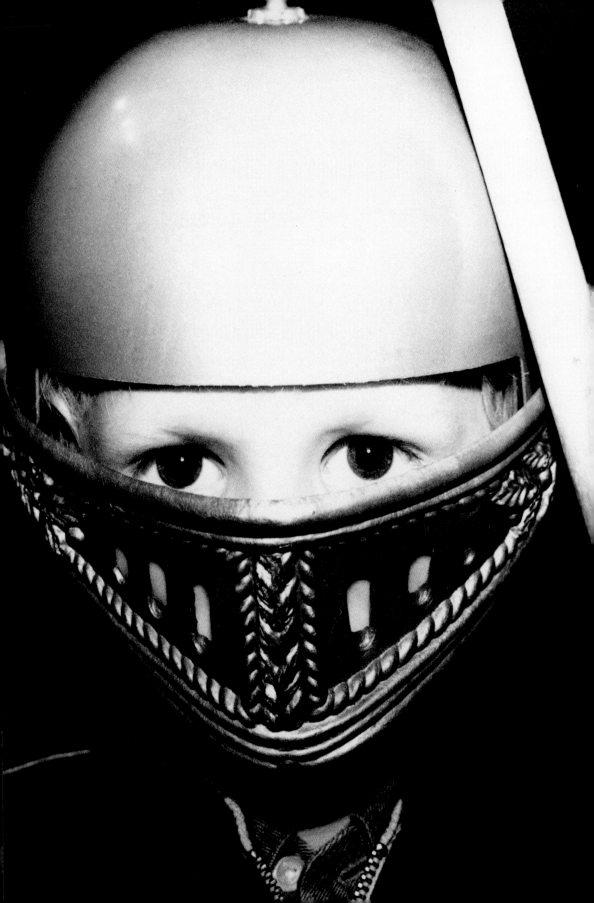

What's great about kids is you can photograph them in very bright light, or hard light. They have good skin and they don't have wrinkles. The harsh light gives them more power. Just remember to put your sunglasses on. And close down. Close down so less light gets in your camera.

A camera lens has all these numbers on it: 2, 2.8., 4, 5.6, etc. Each increment is equidistant, like inches on a ruler. The higher the number, the more closed down it is. You adjust the iris of your camera according to 1) the kind of light that is there and 2) the result that you're looking for. If there's a lot of light, your reaction as a photographer is to close down, i.e., F11. Then you will also have more depth of field, which means that more of the background will be in focus.

In hard light, you will probably also use a faster shutter speed. That means there is less time for the light to get in the eye of the camera. You might also use a slower film, a film with a lower ASA number, like 100 or 200, which means it is less sensitive to light.

Beware, when you take pictures in hard light, sometimes you won't see their eyes.

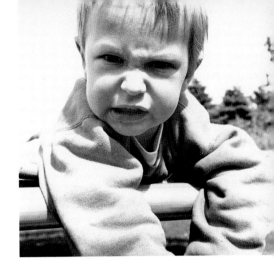

HARD

LIGHT

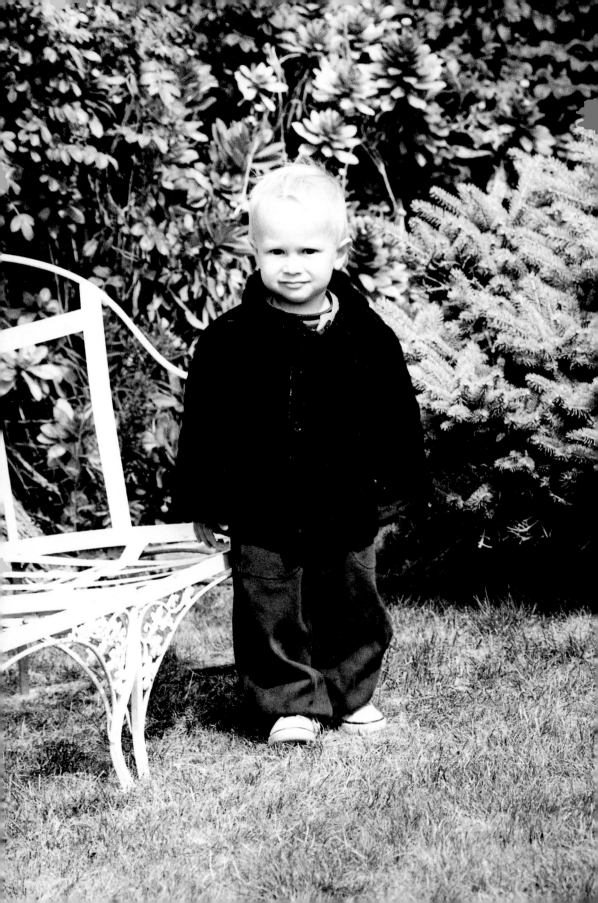

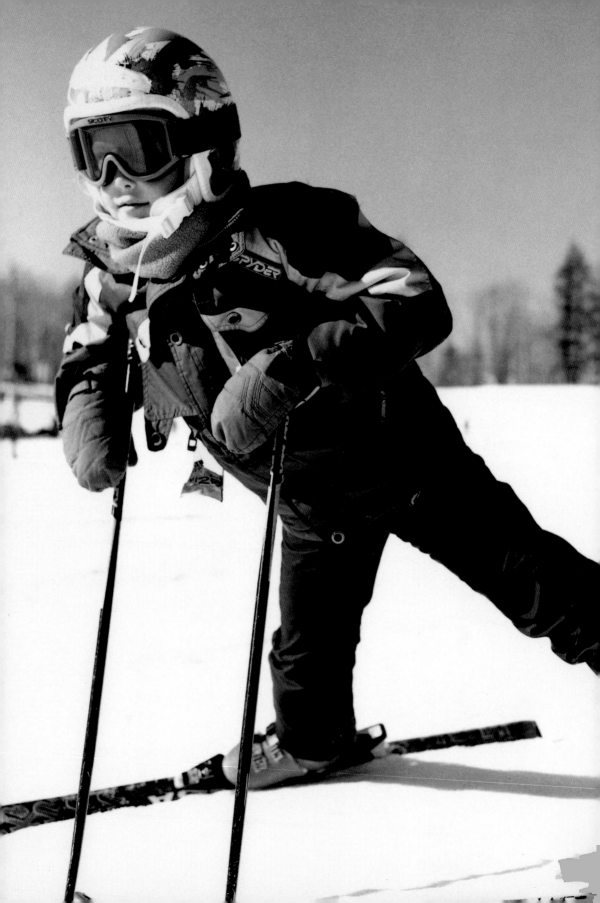

I don't ski, but my whole family does, so they took me to the slopes to pose for me and show me what they do. I have very few ski pictures because I don't ski. Grethe can just turn around and take one, while she glides down the mountain.

Whenever you take snow pictures, don't forget to open up as much as two stops if you want to keep the snow white. If you have a light meter in your camera, take a reading from something gray, like your glove.

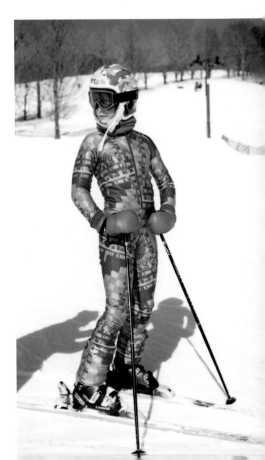

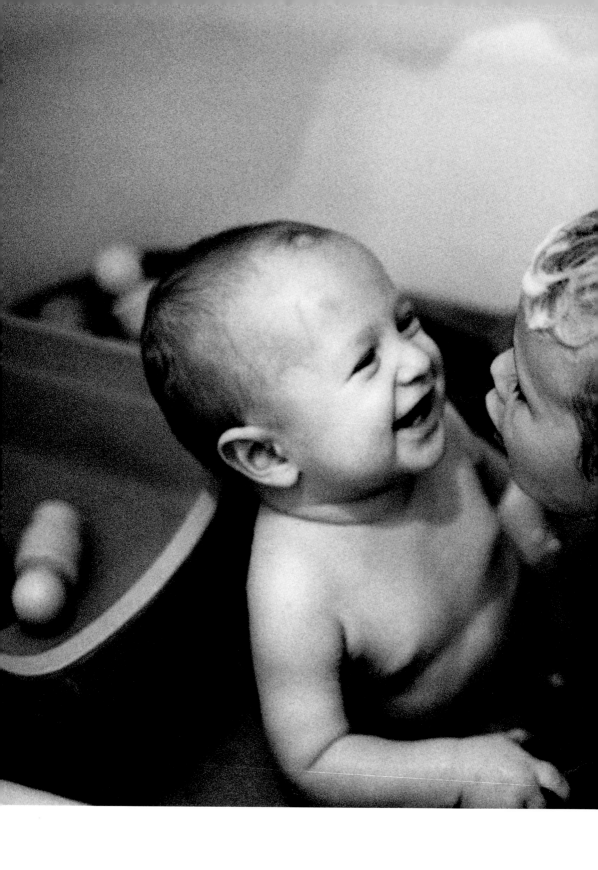

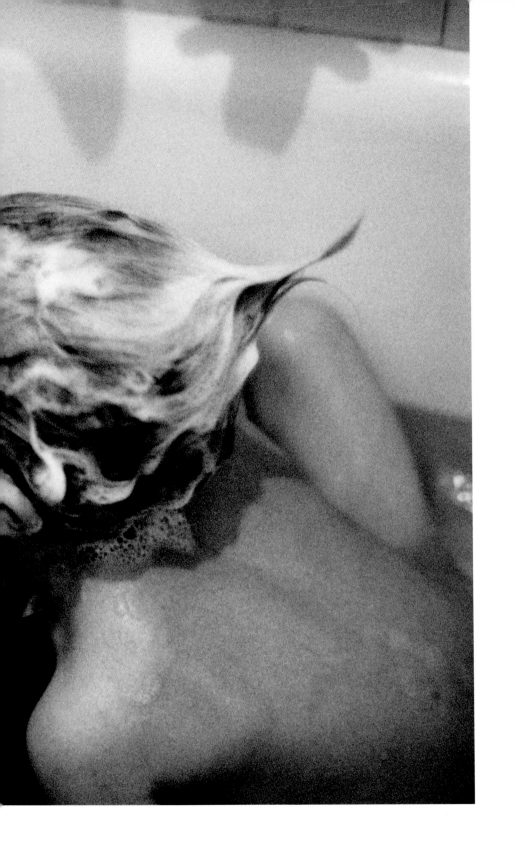

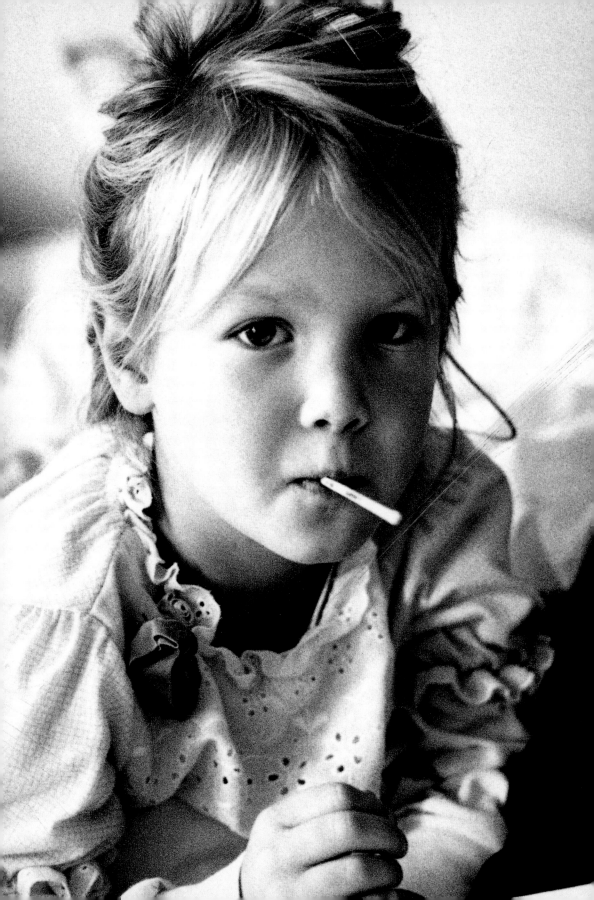

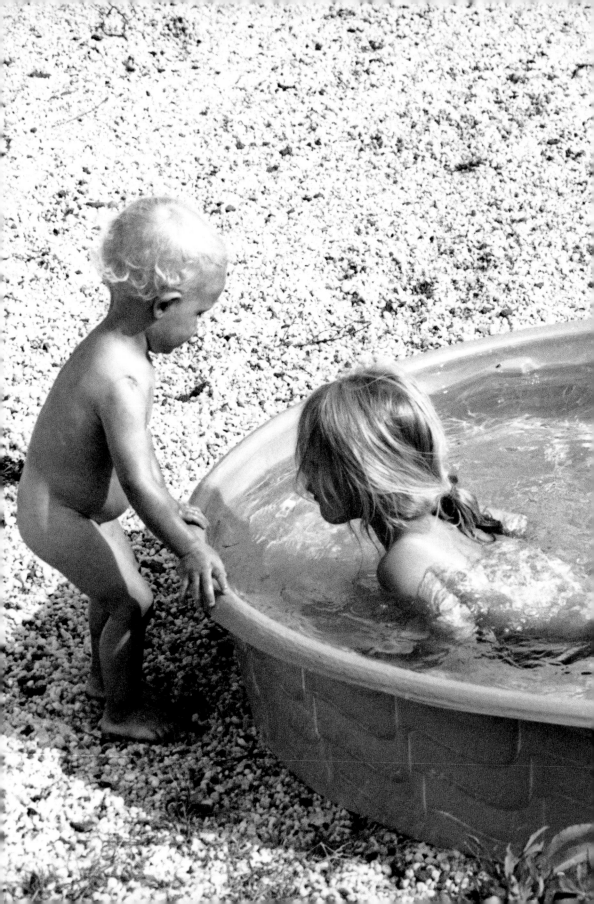

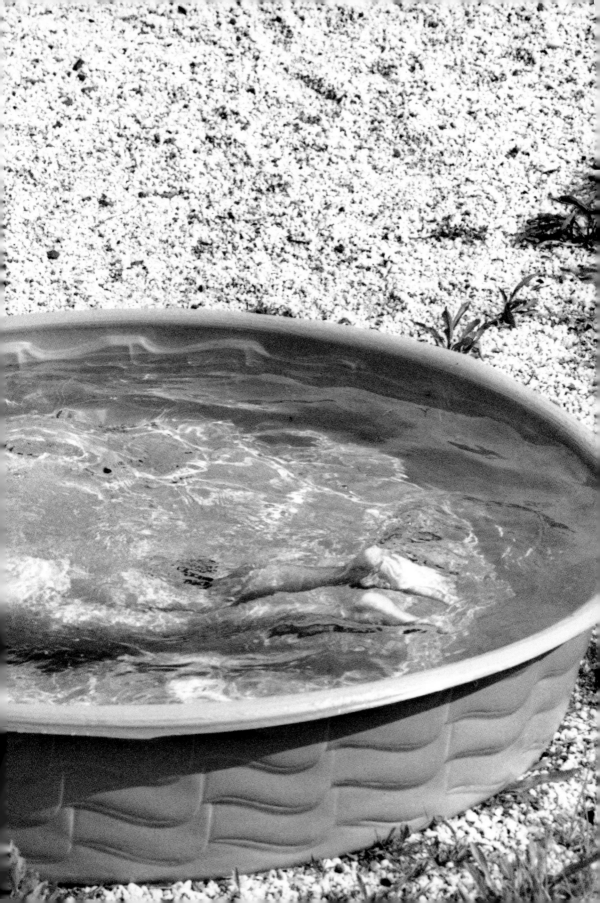

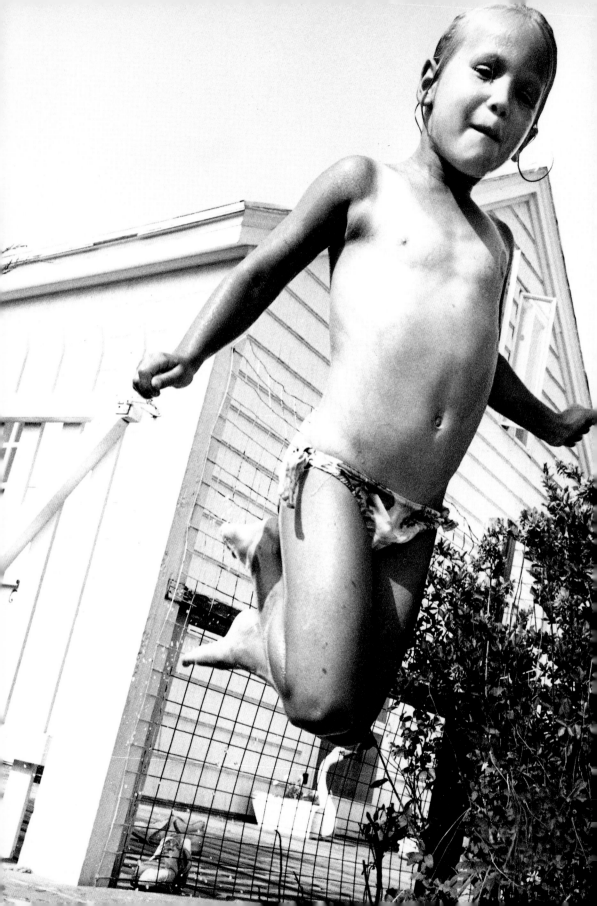

There are plenty of waterproof
cameras around now, so if they get
splashed, it doesn't matter. For
underwater pictures, you're better
off at high noon with the light
coming through. Then you don't
have to get all flashy and fancy
about it.

WATER-SAFE

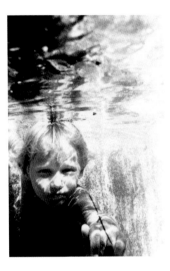

CAMERAS

Good things happen in the swim-
ming pool. Sophie's jumping at
me. I was right there. She almost
hit me. And she loved that. I take
a lot of pictures in the pool.
Finally, I got a waterproof camera.
I preset it and it's fun. I have a lot
of these pictures of Sophie because
she's more watery.

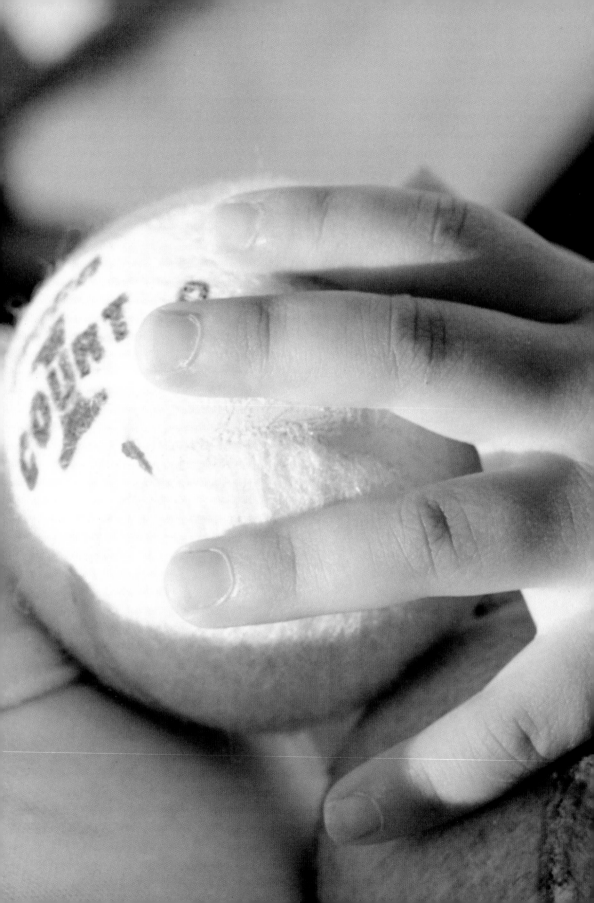

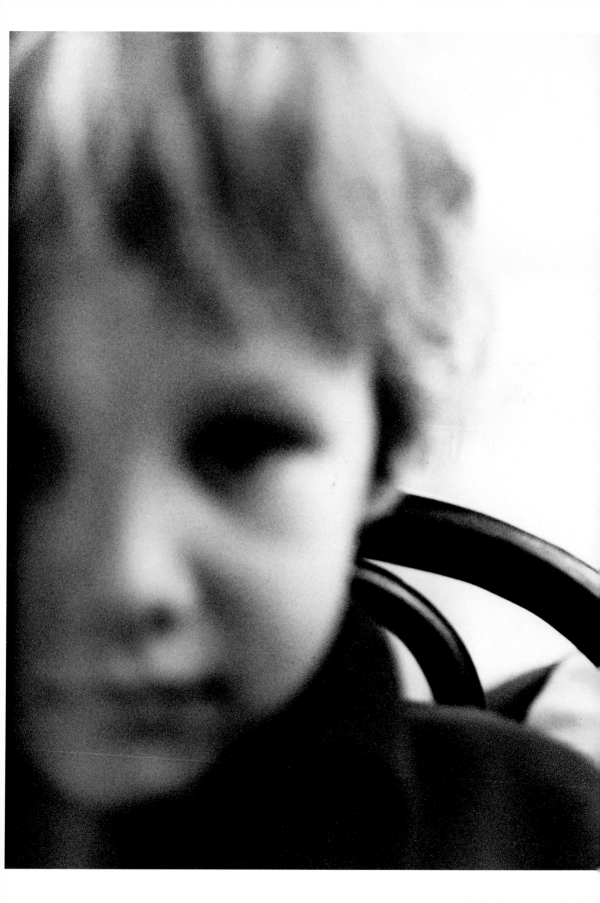

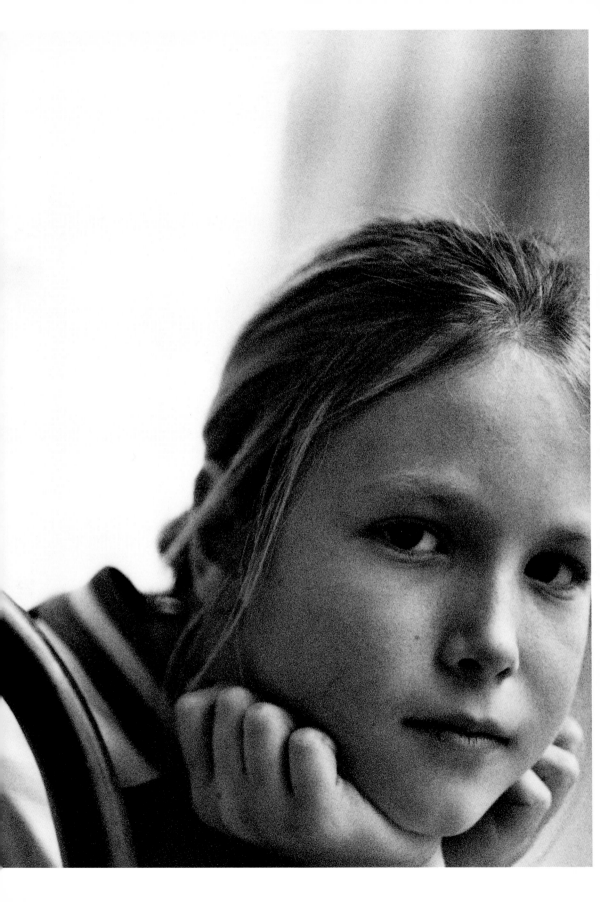

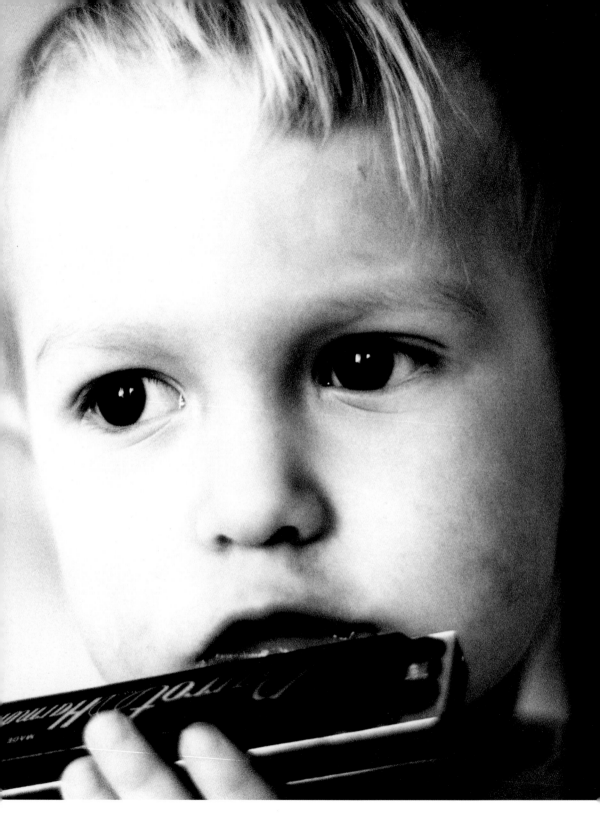

breathe out

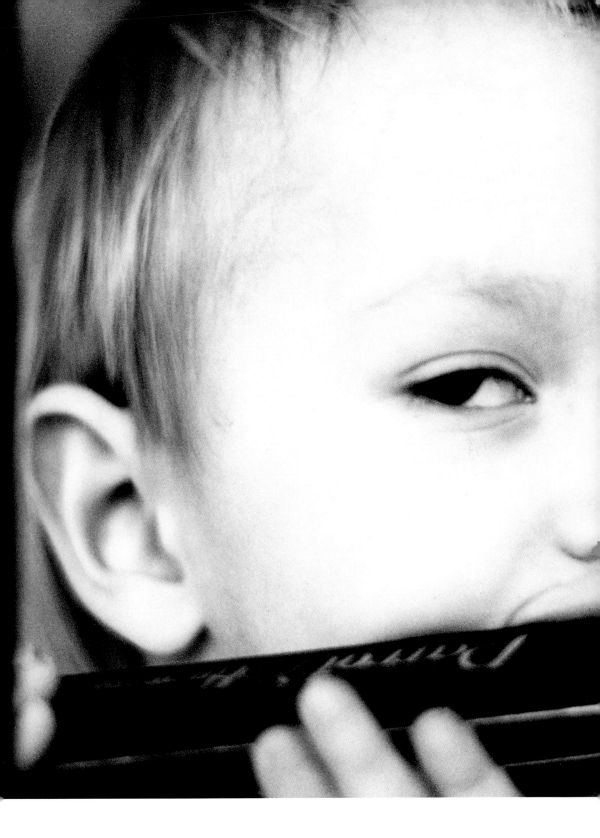

breathe in

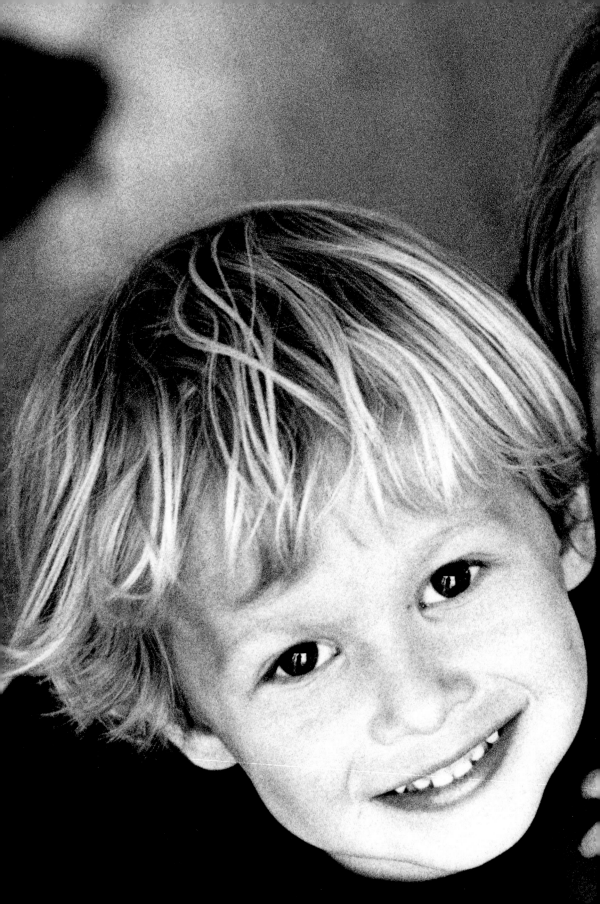

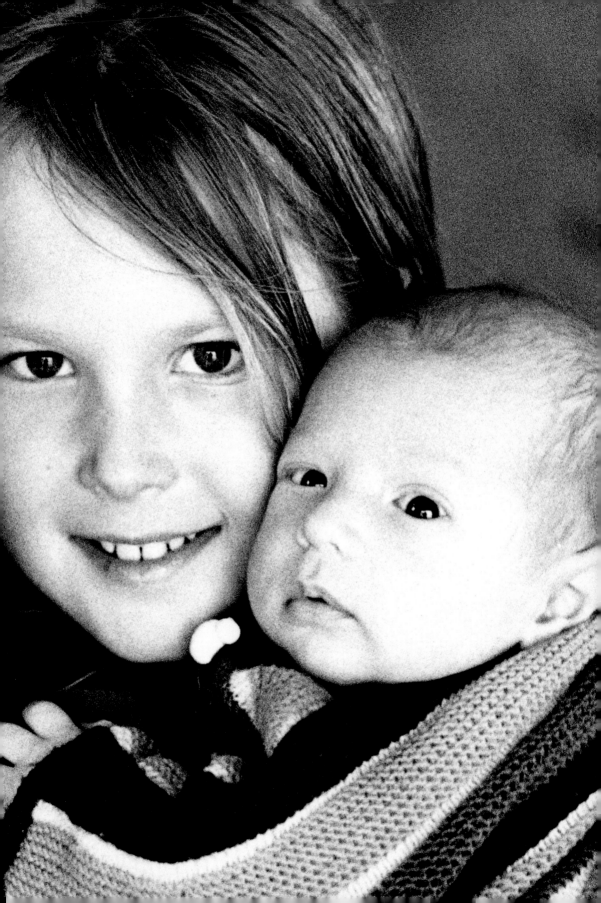

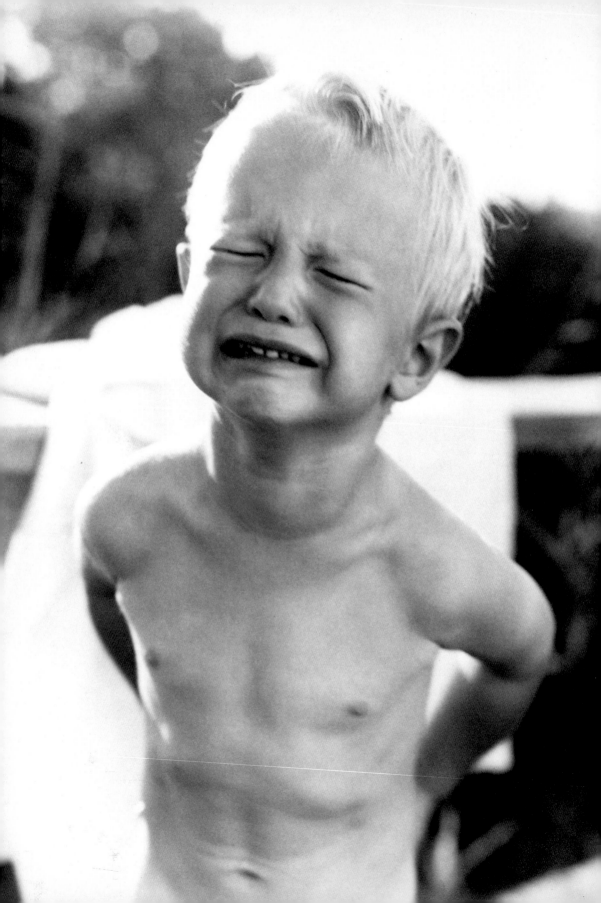

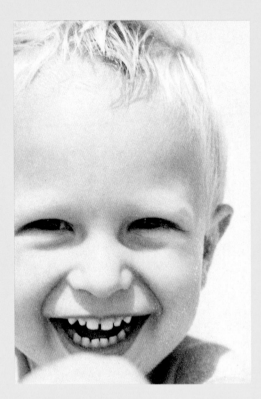

**Things can change from
moment to moment**

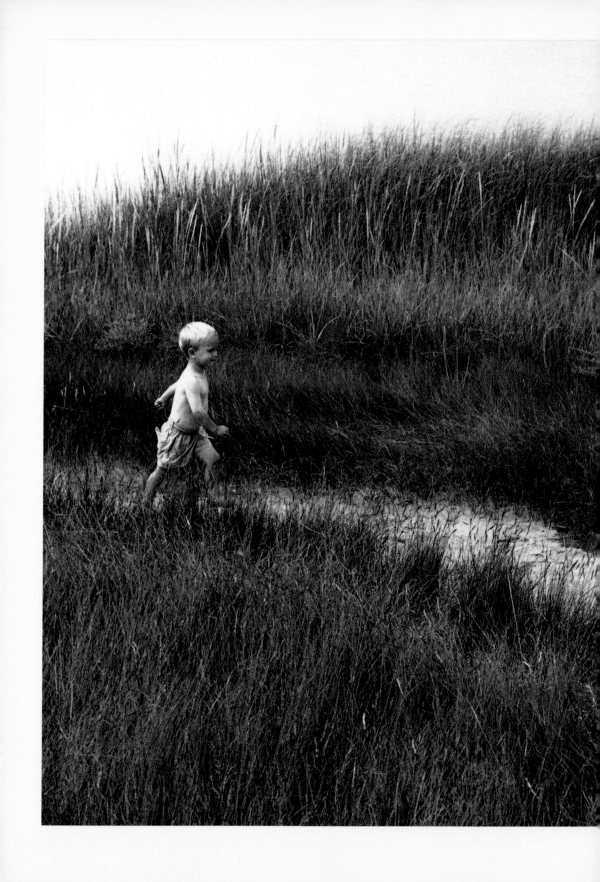

For city kids, when they're in the country, they like to walk by themselves.

They feel like, "We are people, we don't need anyone to hold our hands."

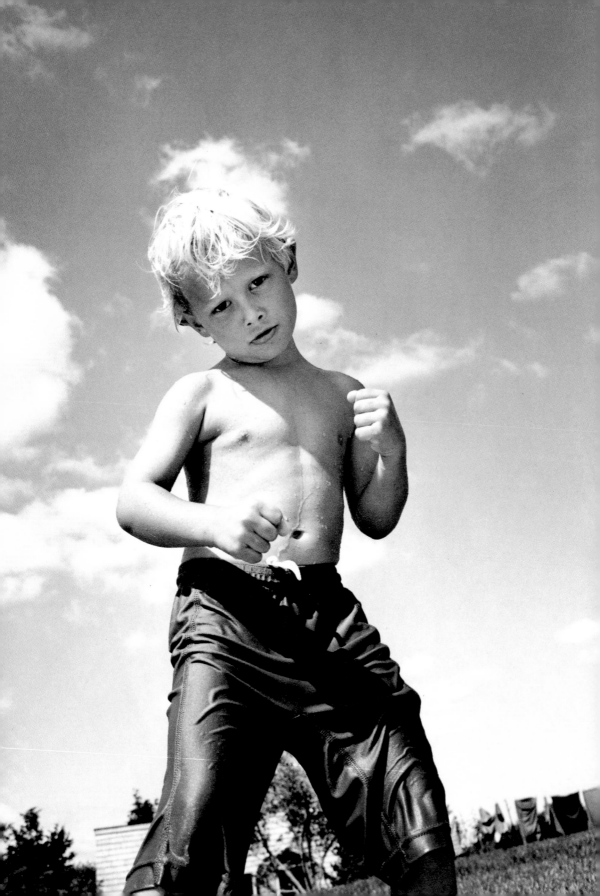

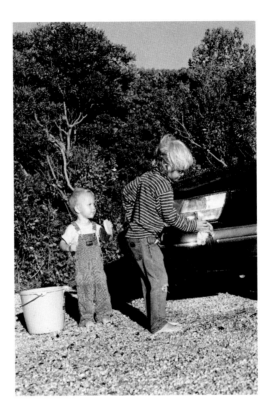

Like anything in life, half of it consists of relaxing as best you can, but still having reflexes enough to

anticipate. To see. And to get the picture.

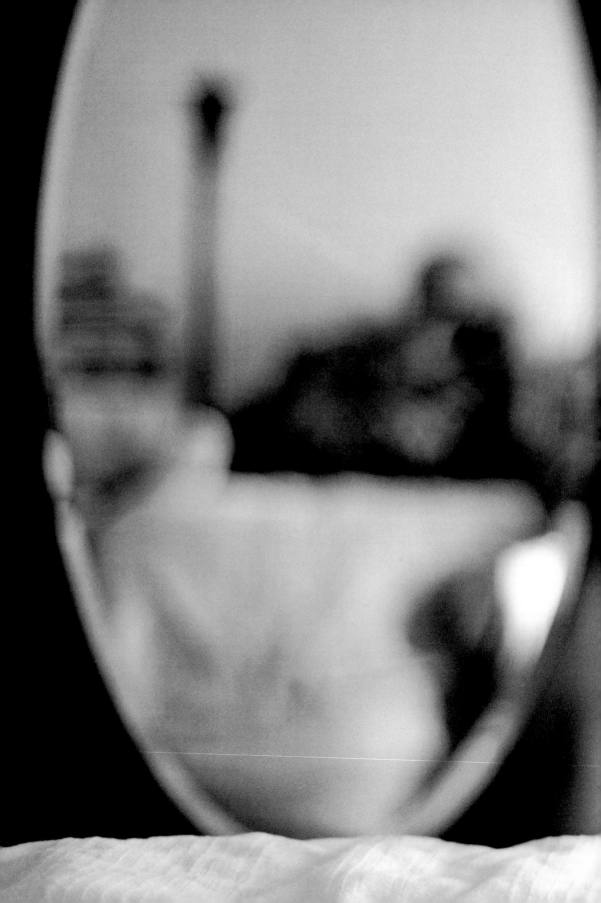

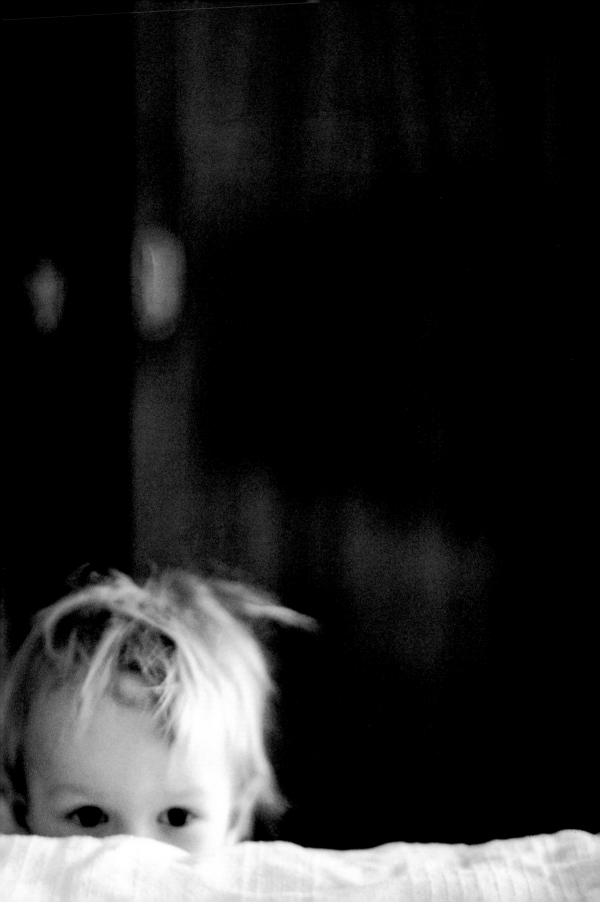

look

at

They're thrilled if you take a shot in recognition of an

accomplishment. There's a joyous something about it.

me

!

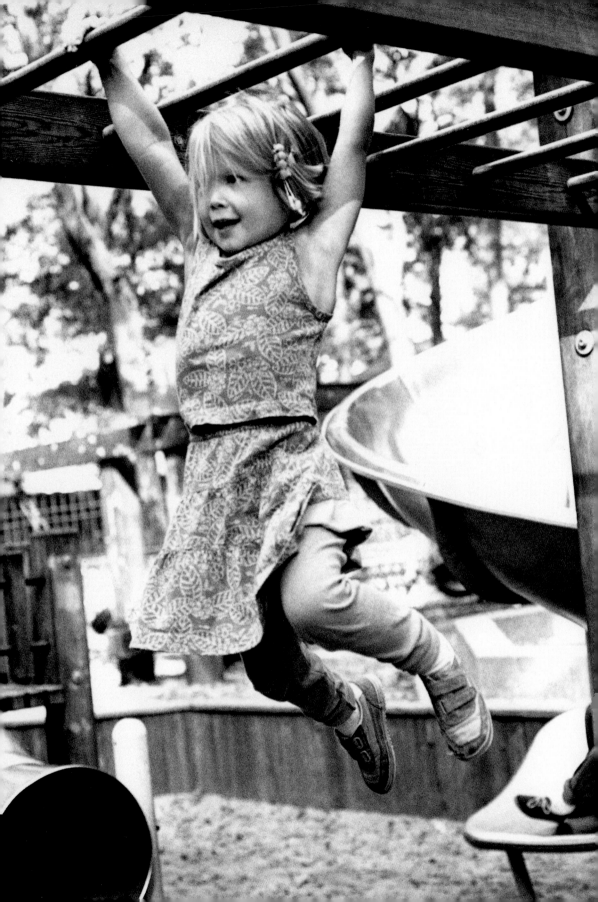

WHAT'S NEAR IS GOOD

We all have our favorite spots. A neighbor was telling me the other day, "I know the place I like best in this house — it's right here on this bench." We all have a safety. In the city, I sit in the kitchen. In the country, I'm either in the living room, beside the record player or I'm at the front door. It's a sure bet. Sooner or later, a picture is going to come into my camera.

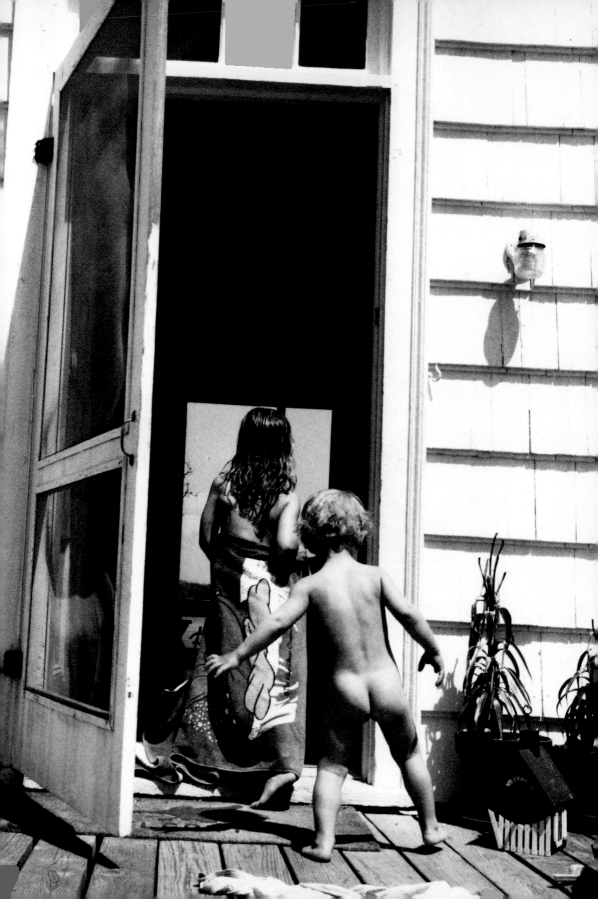

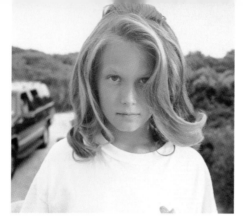

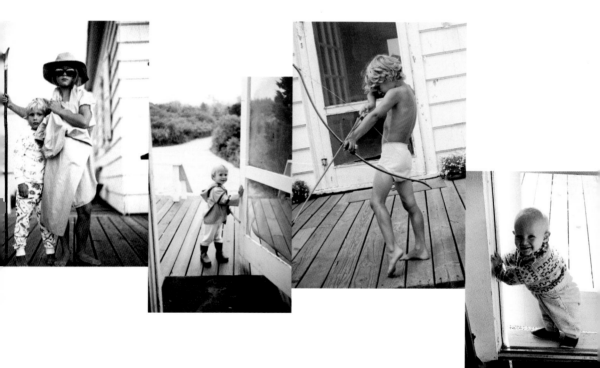

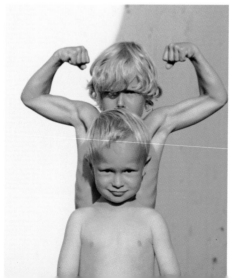

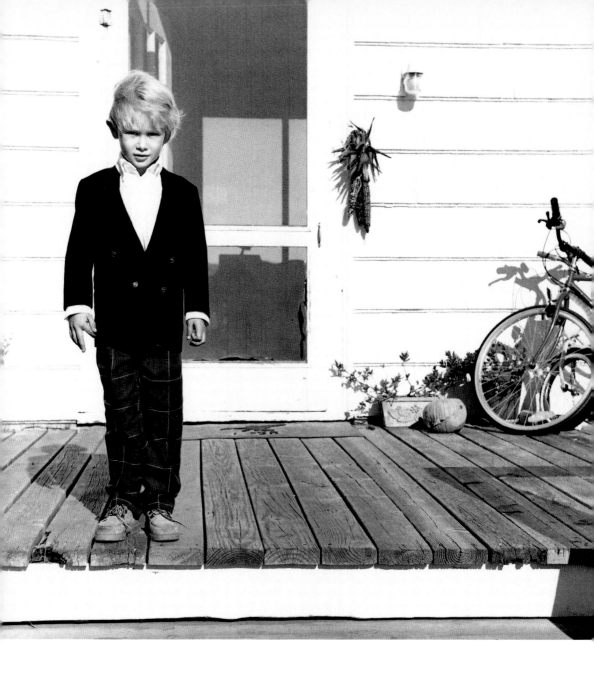

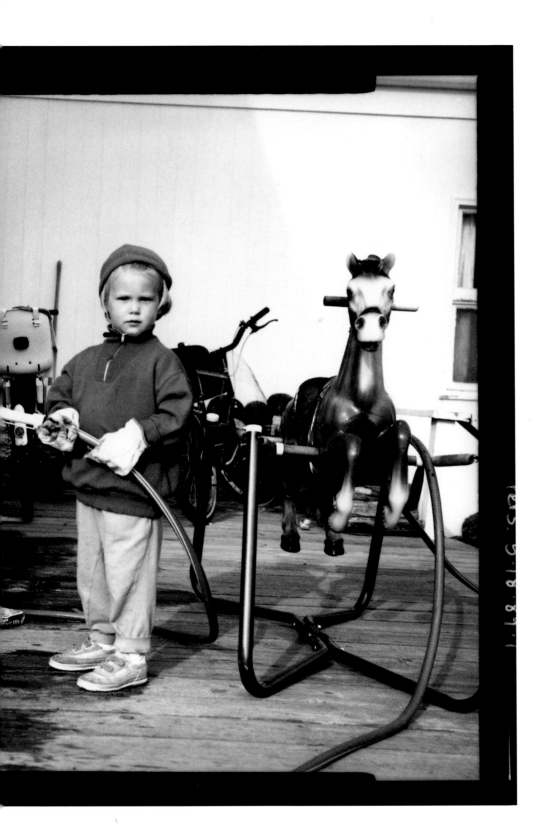

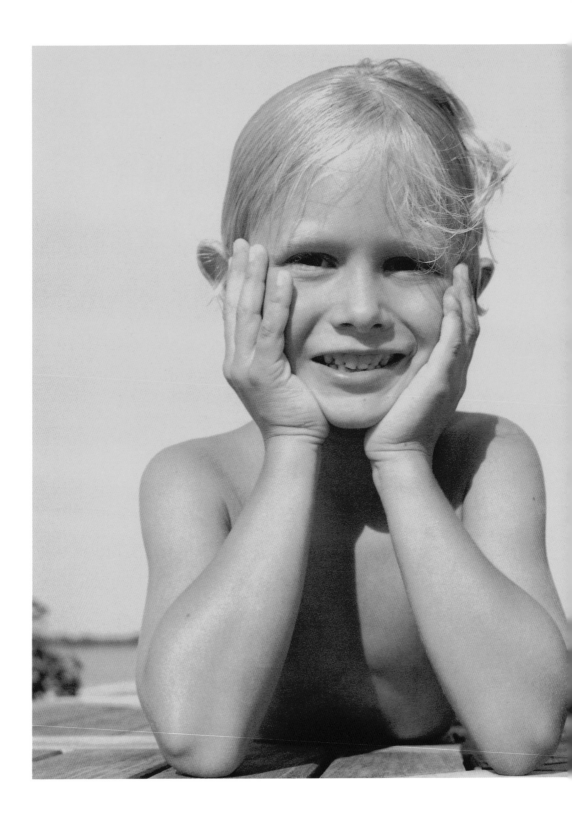

CAN I TAKE A PICTURE OF YOU ?
AND THEN HE WAS GONE
(ONE FRAME AND GOODBYE)

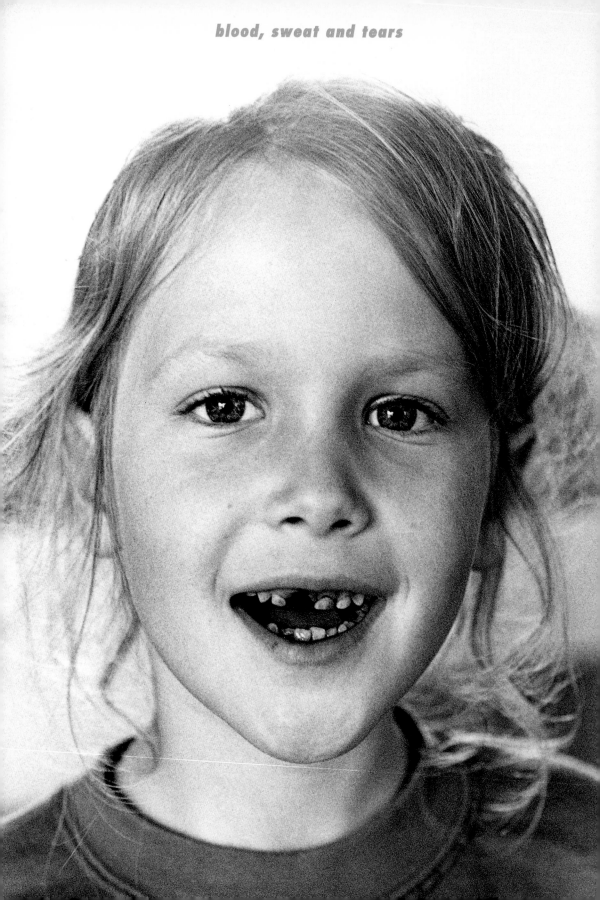

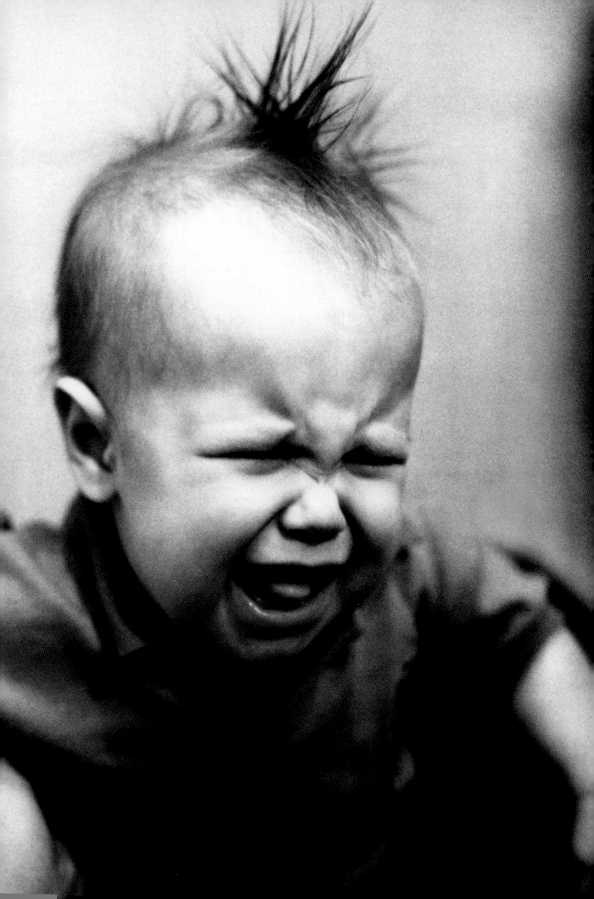

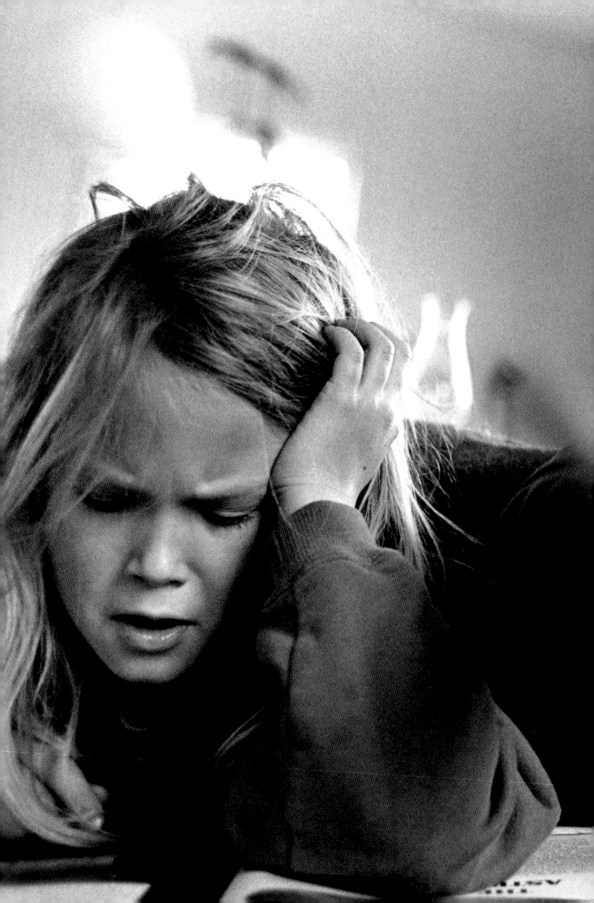

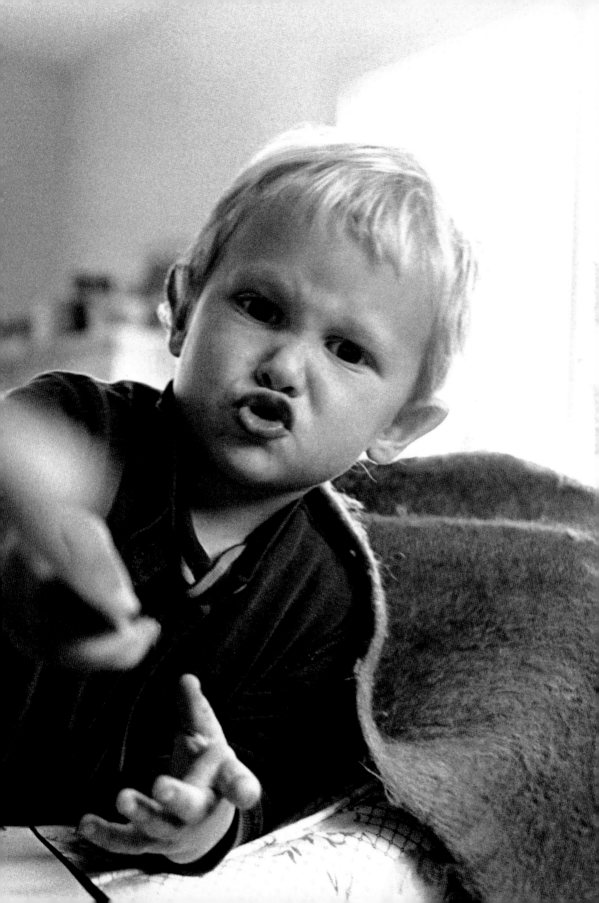

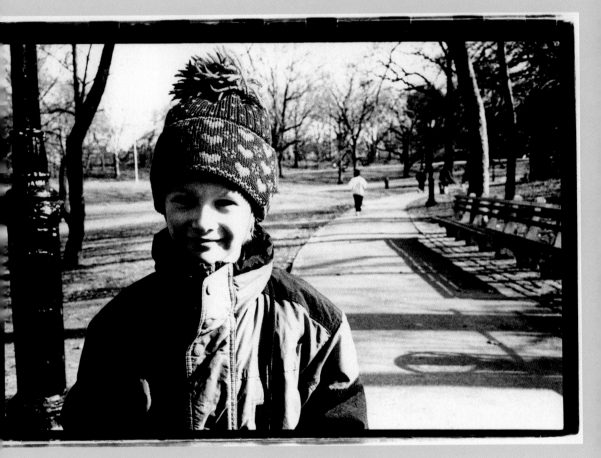

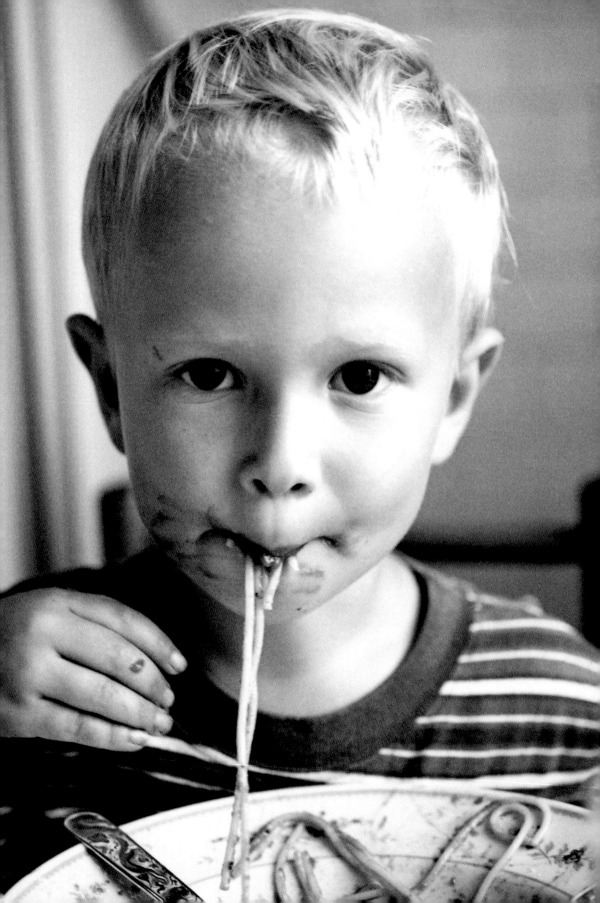

BREAKFAST

LUNCH

DINNER

The table is a good place to shoot: they're captive. They don't go anywhere. They're sitting there and they're waiting for something. Sometimes I won't even show the table, it'll just be this close-up of their face. At meals, we're usually on a fairly eye-to-eye level. The table keeps our height pretty much the same. When they're walking around, it's a lot harder.

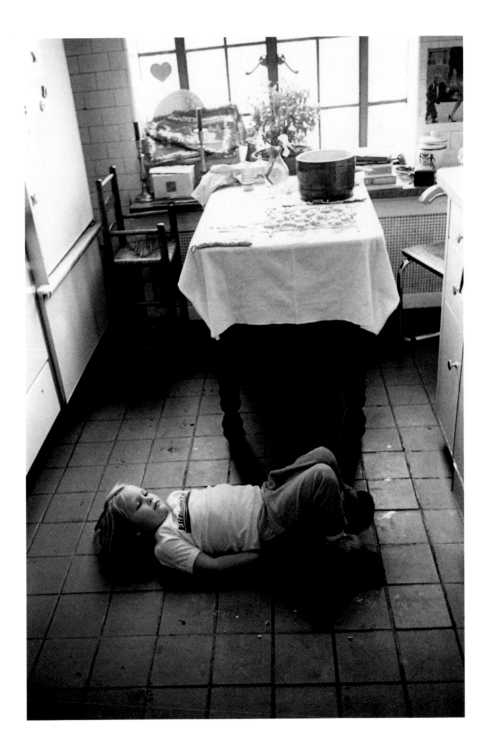

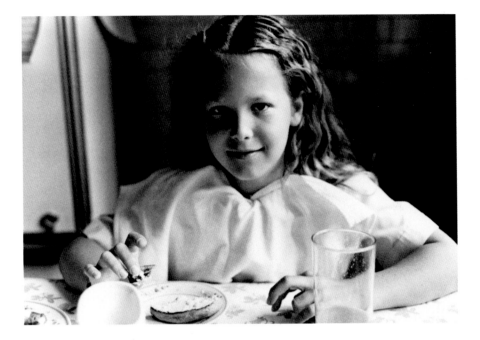

KITCHEN STORY

The kitchen, for me, is the easiest place at home to score. Because that's where I'm usually with

them. It's a small kitchen, but it has beautiful light.

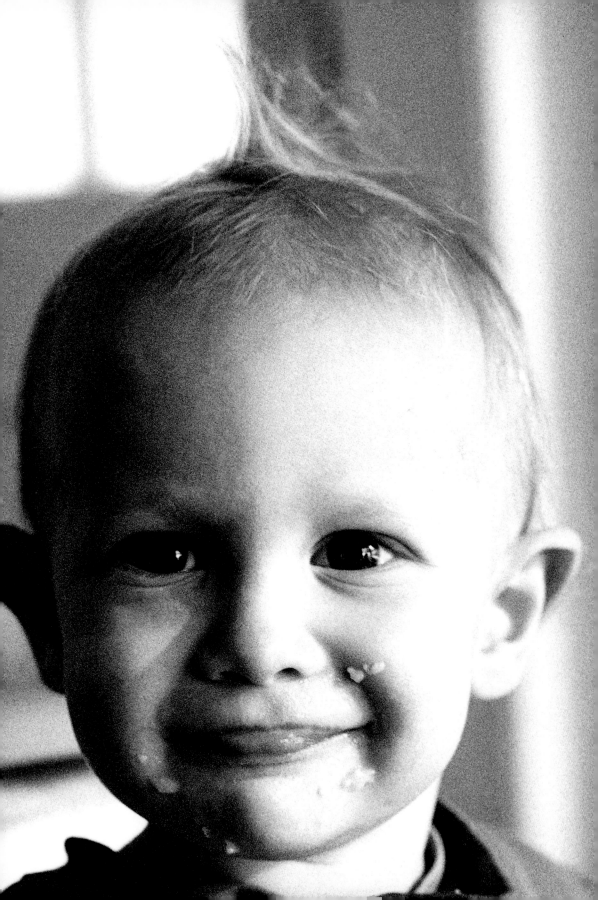

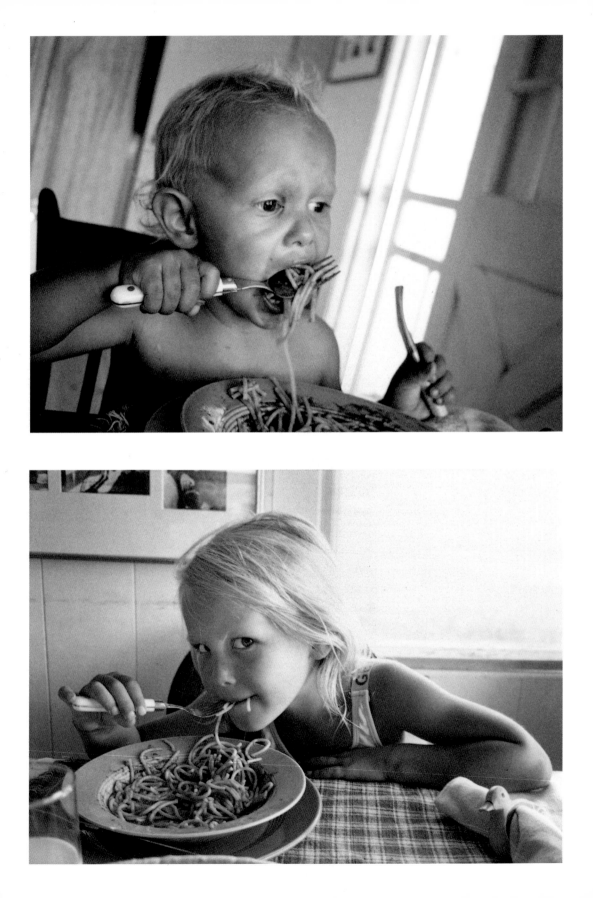

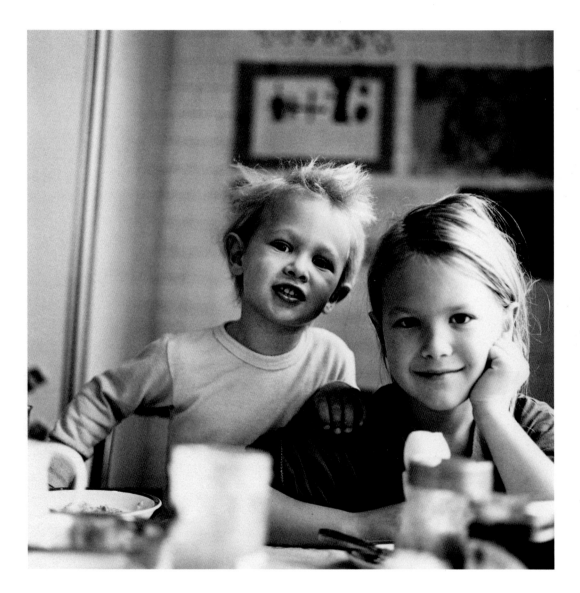

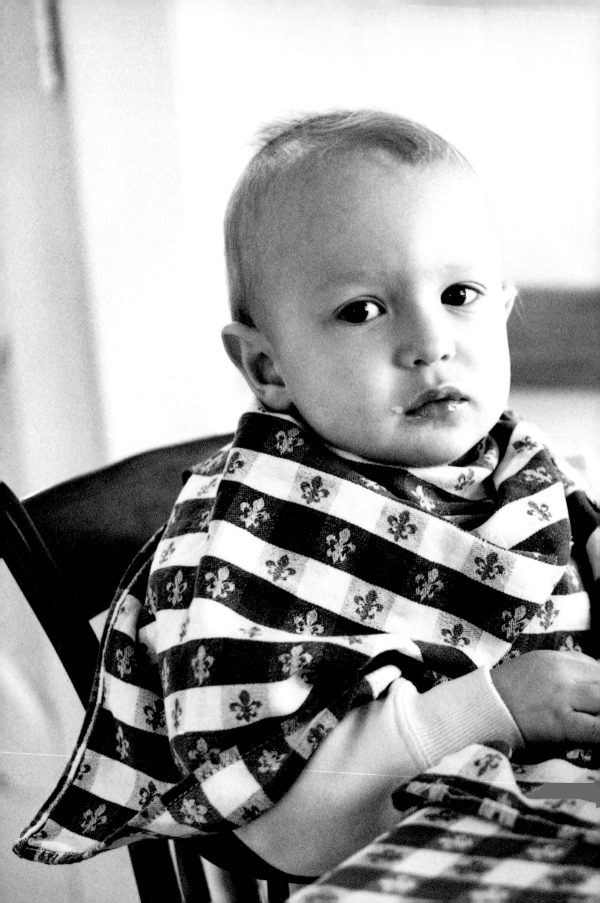

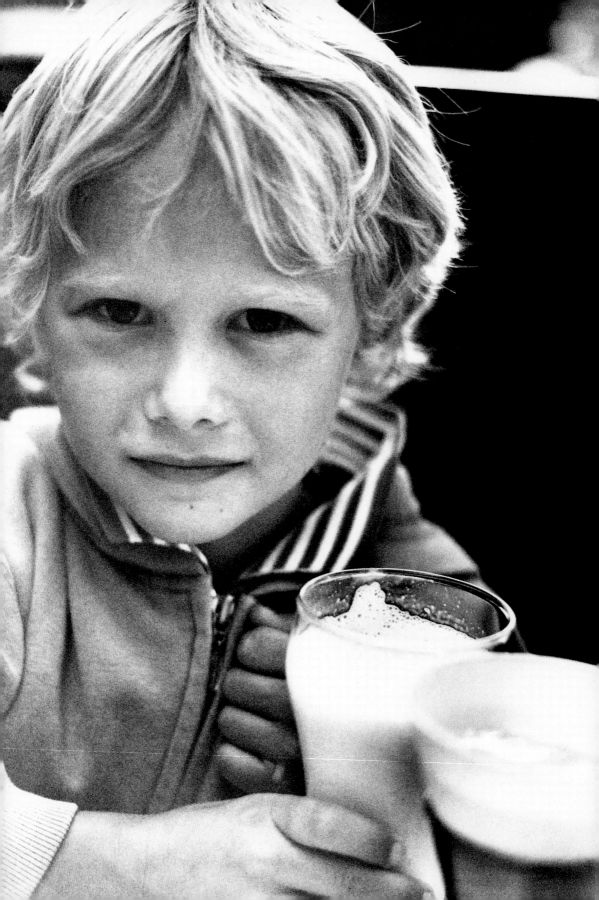

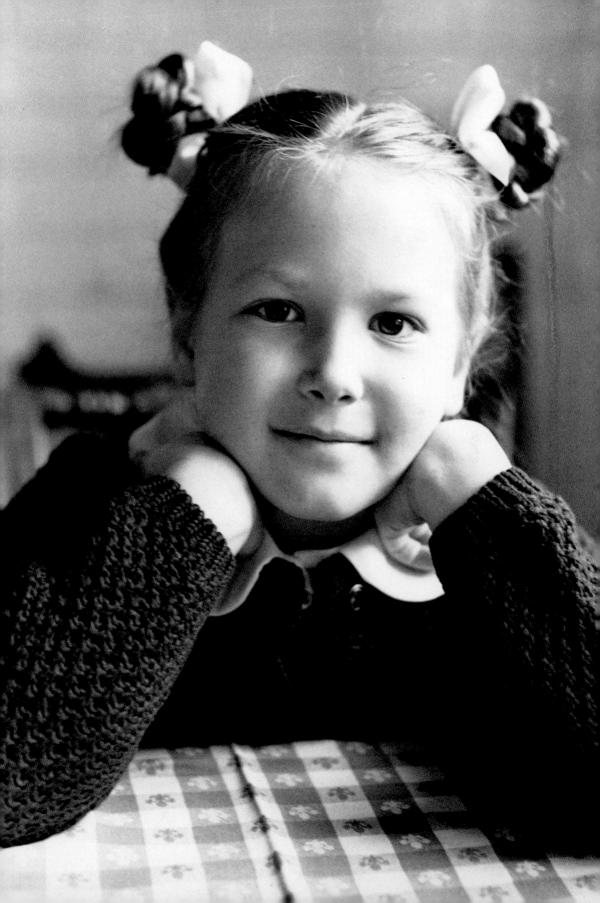

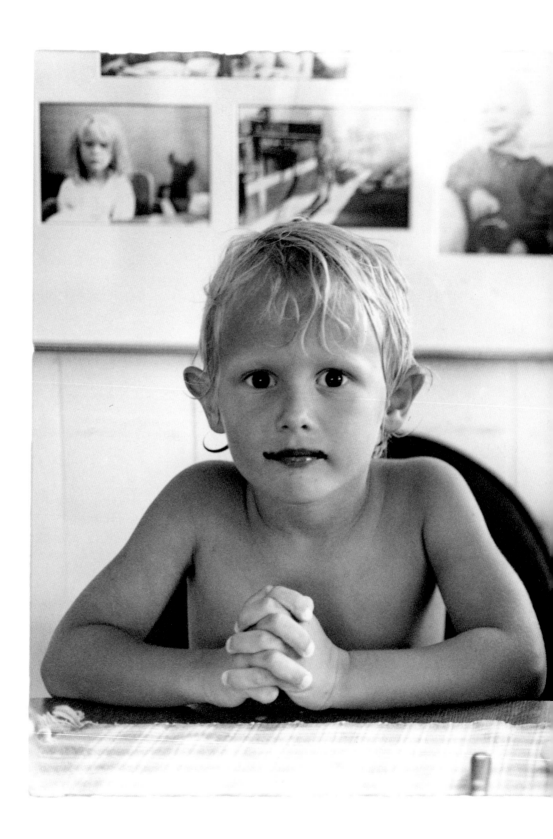

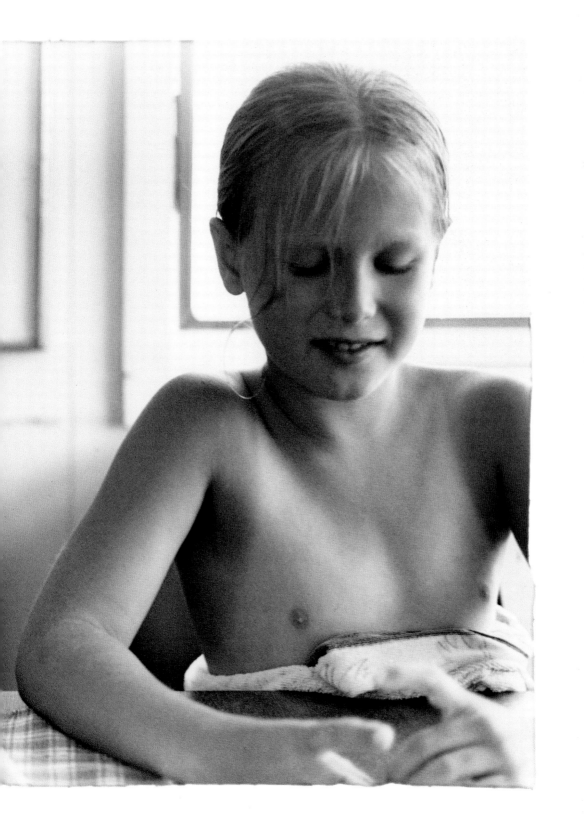

Why lunch? Because I'm there.

Warren said, "Daddy has to have his camera just like Ansel has his ganky." The ganky is one of Ansel's last things of babydom. It goes wherever he goes. Sometimes he'll take it upstairs and stand at the top and drop it down to the floor. Then he'll run down and grab it and throw himself onto it and go, "Ohh, ganky!" It's such a mess. It's been completely patched and sewn up because he'll bite it or rip it or drag it. Lately, he'll leave it for a little while. But then he'll panic, "Where's my ganky?"

Maybe my camera is a security blanket for me.

As a professional, this is the only time I'm not being told what to do. No one is standing behind me saying, "Don't come in too close." The thing about my family pictures is that they are real. There are no rules. They are wonderful, organic, natural opportunities. It's a release.

I love action pictures. I love angle and impact. I like the movement and there's something heroic about them. There's a kind of pride about them. The kids are always excited to see them. They say, "That's me, huh? Looks pretty good." They have to work for them. And you must be fast on your feet. You have to catch it in one snap. Take the picture — and then pick up the ball and shoot the next basket. Now, if I could have a camera attached to my head...

And then there are after-the-action pictures.

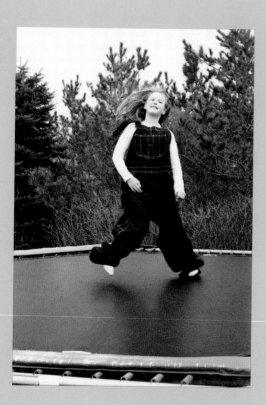
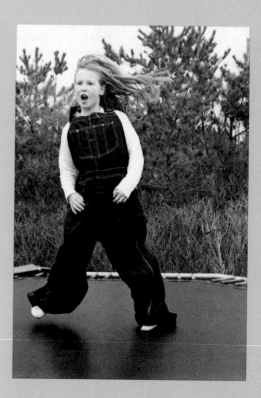

ACTION !

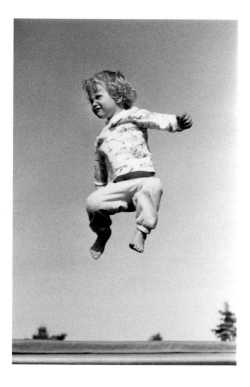

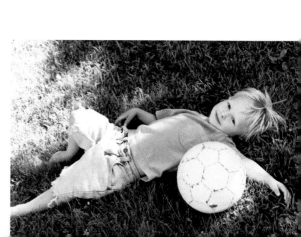

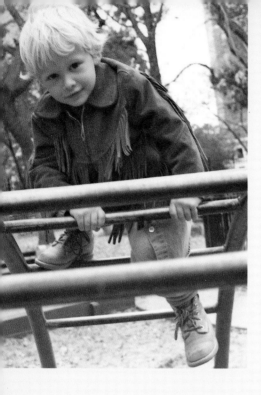
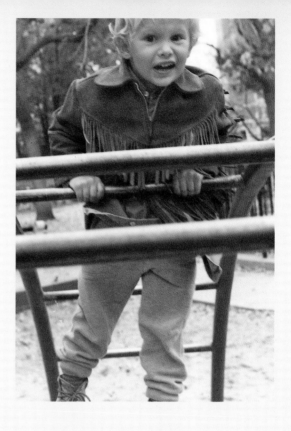
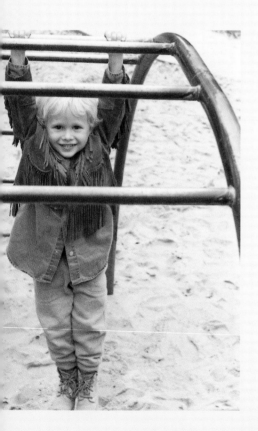
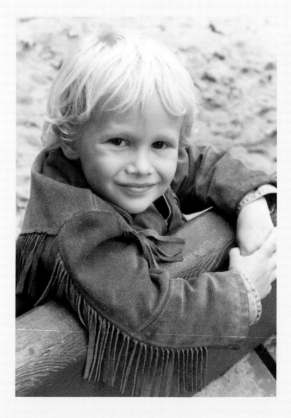

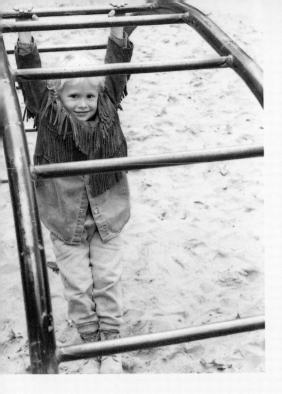

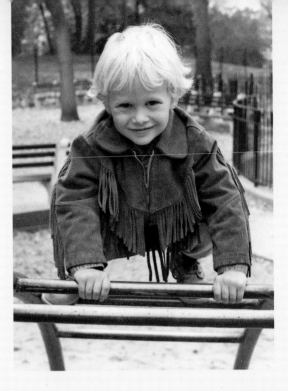

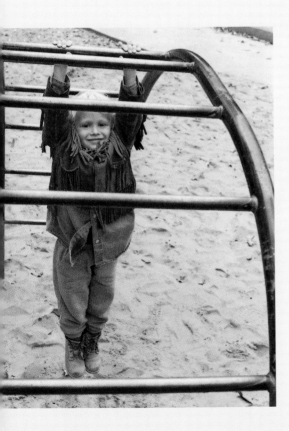

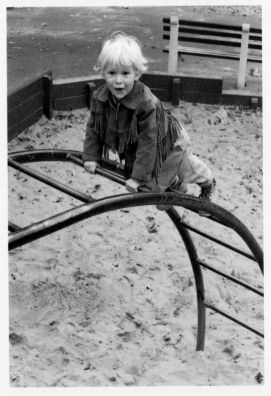

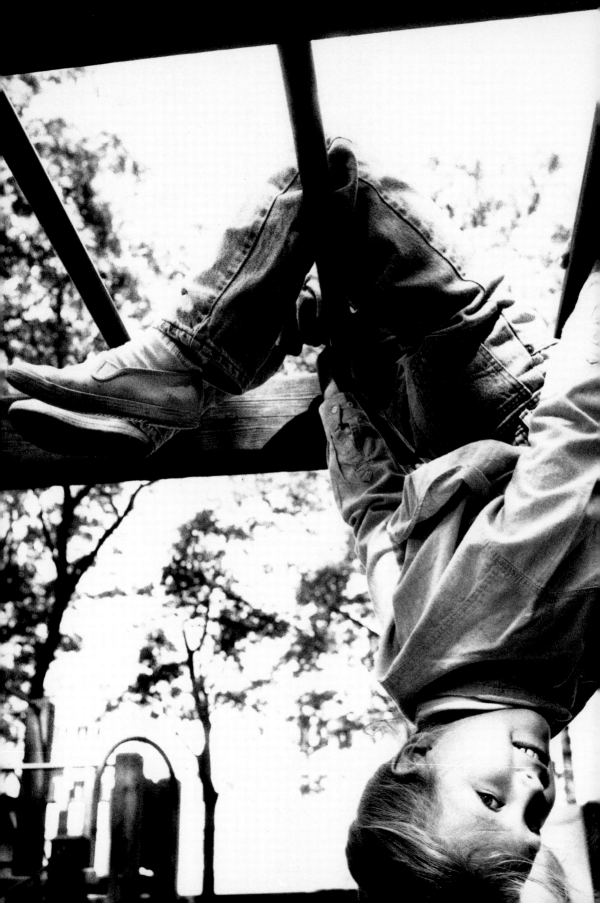

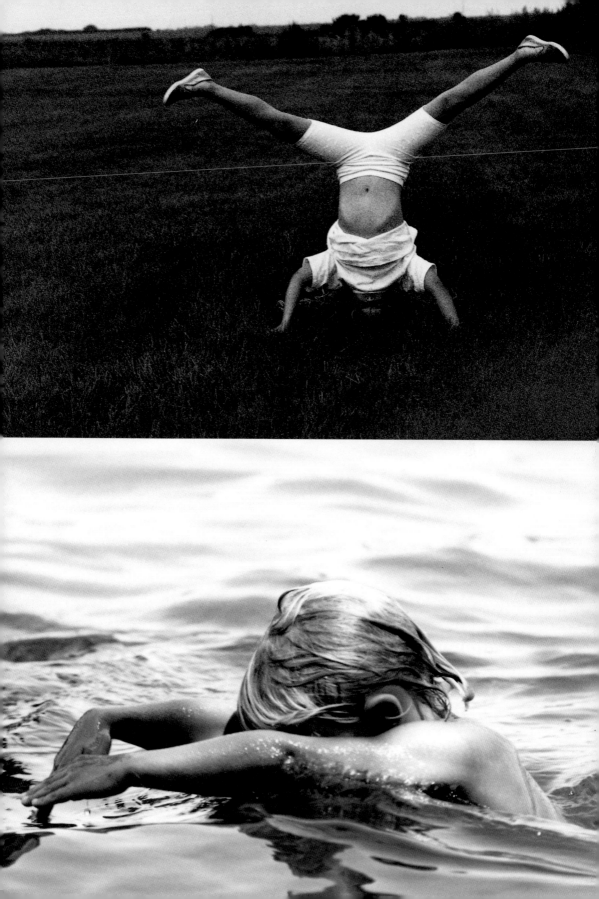

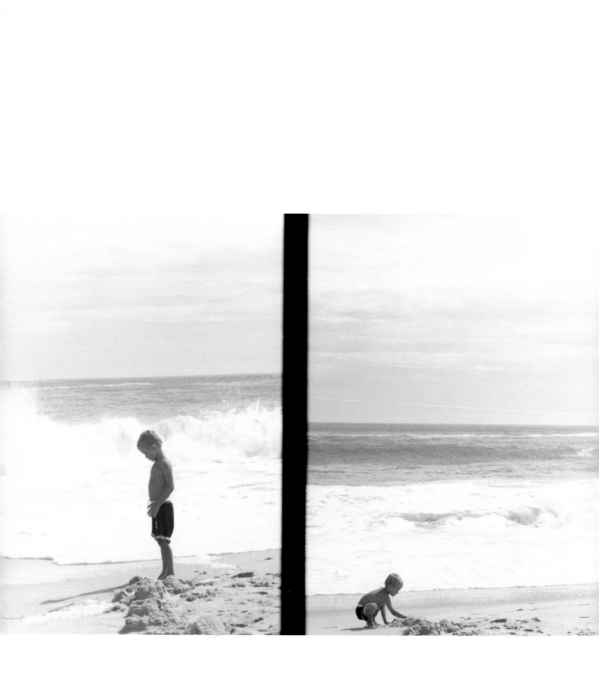

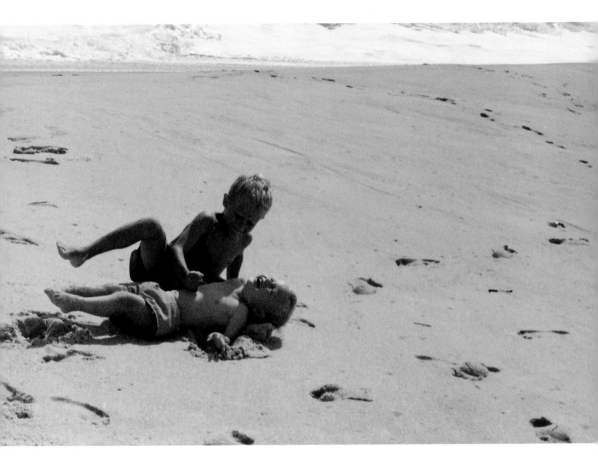

To get a silhouette, set your meter for the lightest thing in the picture and close down the lens one or two stops.

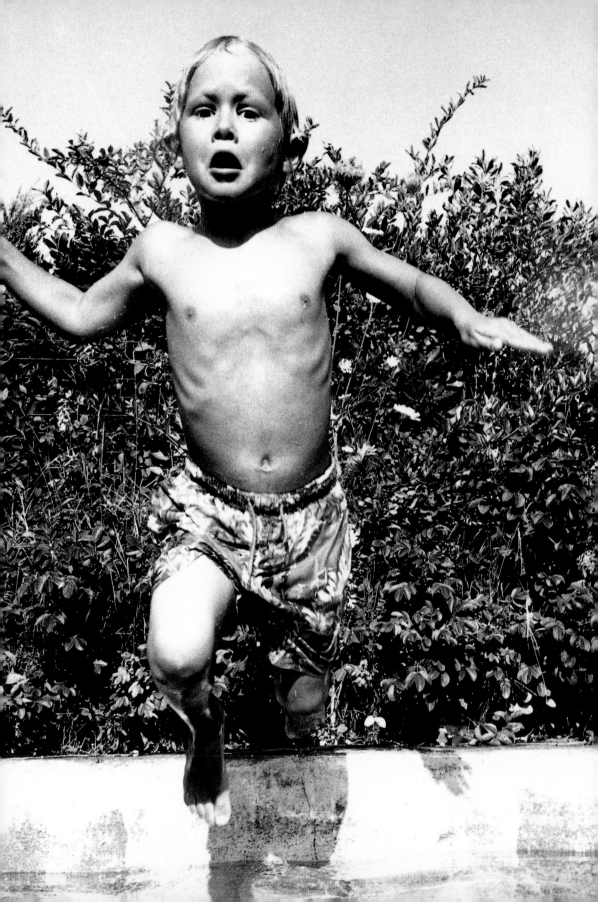

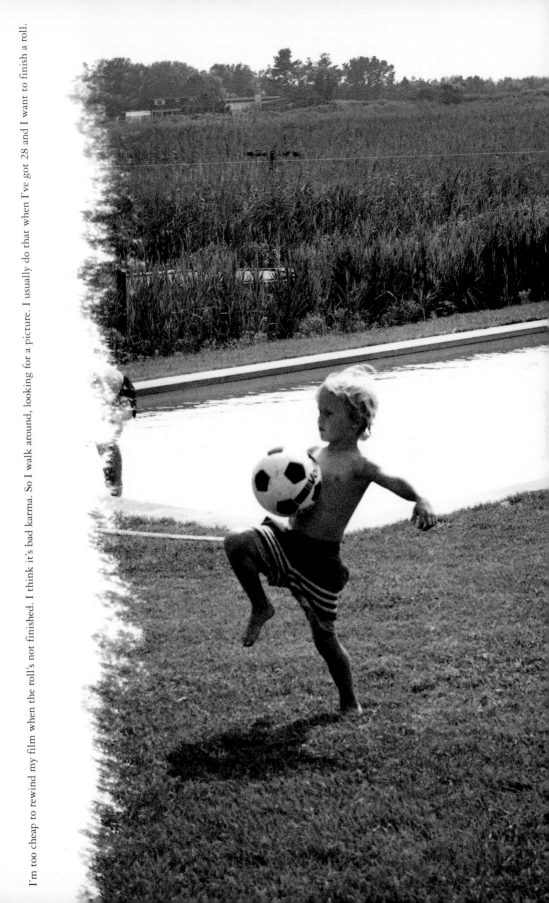

I'm too cheap to rewind my film when the roll's not finished. I think it's bad karma. So I walk around, looking for a picture. I usually do that when I've got 28 and I want to finish a roll.

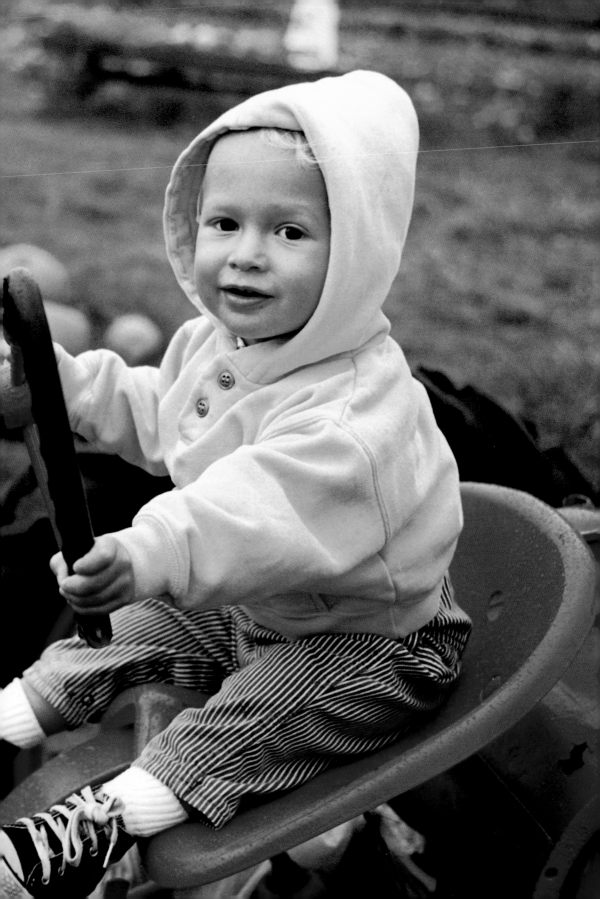

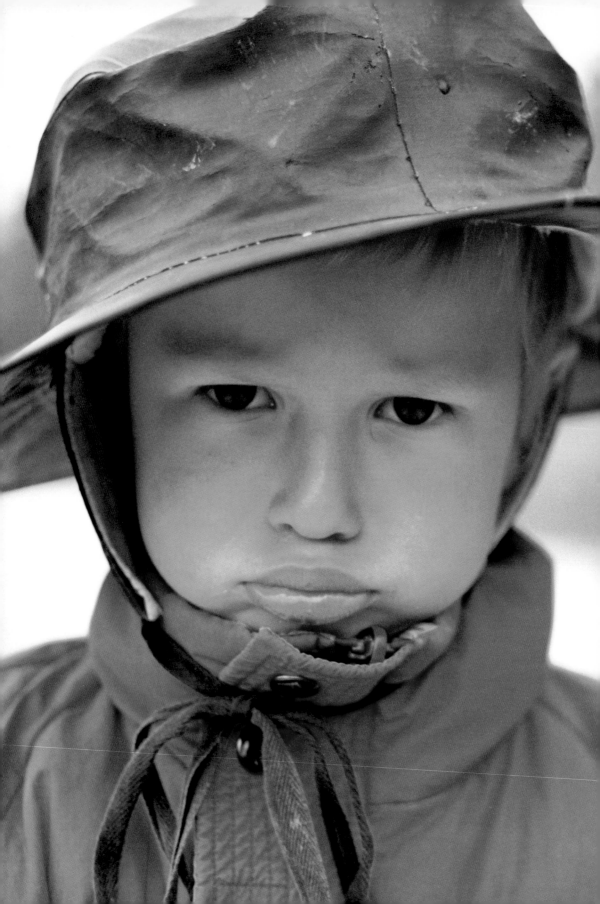

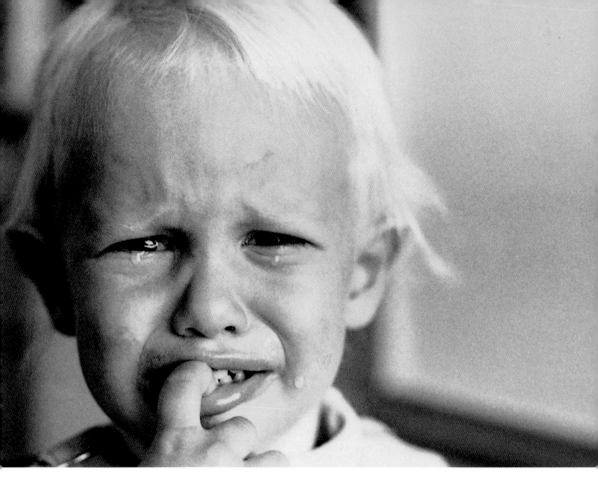

crying's part of life

I wish I had more shots of that. It's
not that my children don't cry. It's
just that sometimes I feel like then
I'm crossing a line and really
invading their space. But there are
times when I have to do it.

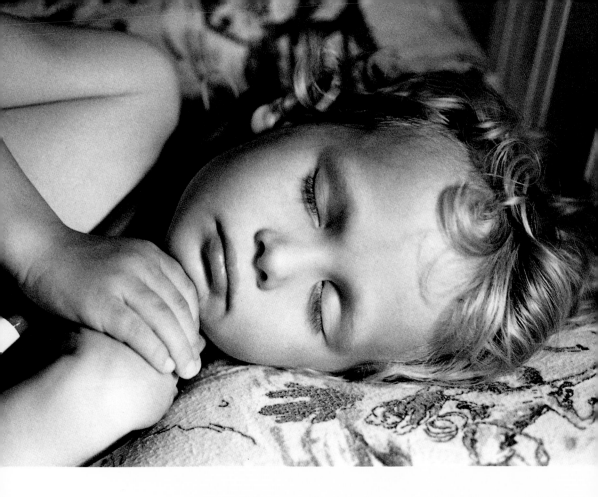

don't they look beautiful when they're sleeping

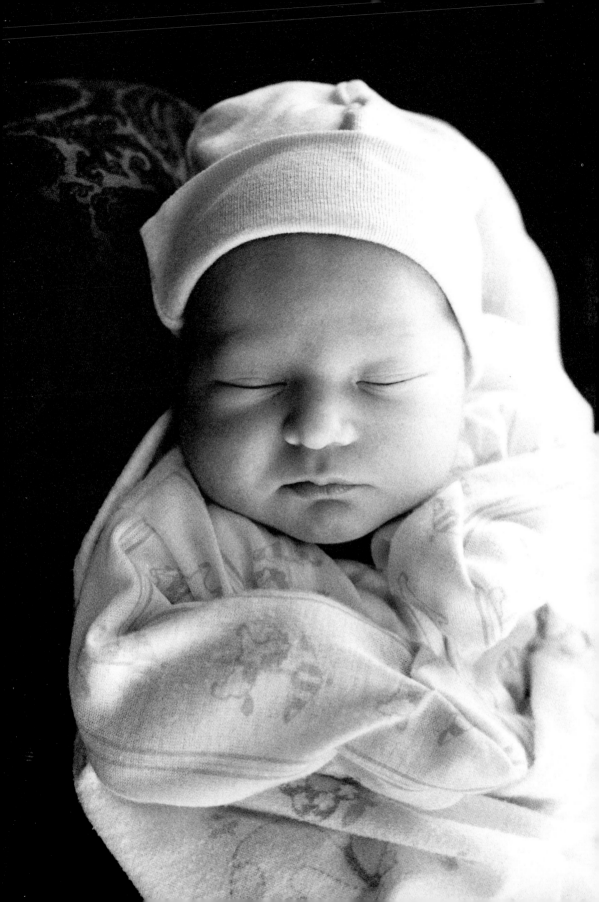

The ultimate

changing-table

picture:

three in the

morning and it's

just the two of us.

It was my

turn to change

her and see

if I couldn't

get her

back to sleep.

And the

camera kept me

company.

It's a very

peaceful picture.

Now, it's

in our bathroom

and I can

look up at it whenever

I want to.

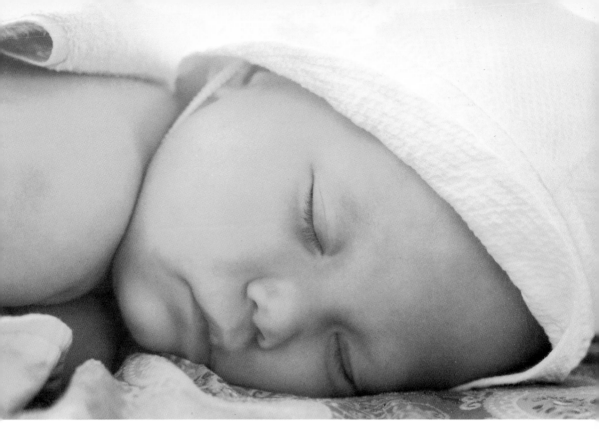

OUTDOORS

The nice thing about taking pictures is is that there are heights and you can attain them. Your children are always around, so why not practice on them, and share it with them? Just don't be a heavy about it.

My children have accepted me as a person who has an ongoing relationship with cameras. They have perceived that I'm perfecting my craft and using them momentarily. I never go gangbusters about it.

In the country, the porch serves as my very sloppy studio. And if passersby, like Warren, see me, they give me one big one, and then hightail it out of there. Then I just wait for my next victim. They'll do it if you're fast. If you're slow, forget it.

In this instance, there is a lot of light in the foreground, but I'm inside. So I open up the lens a stop, maybe even two stops. Open up if you don't want a silhouette surprise.

Remember, indoors, use a slower shutter speed: 1/30, 1/60, 1/125 and a more open lens: F1.4, F2, F2.8, F4. Outdoors, close down the lens: i.e., F5.6 to F11, and use a faster shutter speed: 1/250 to 1/1000 to stop the action.

To save time, you could preset your camera. For this picture my camera was preset at 10 ft., shutter speed 1/25 at F5.6.

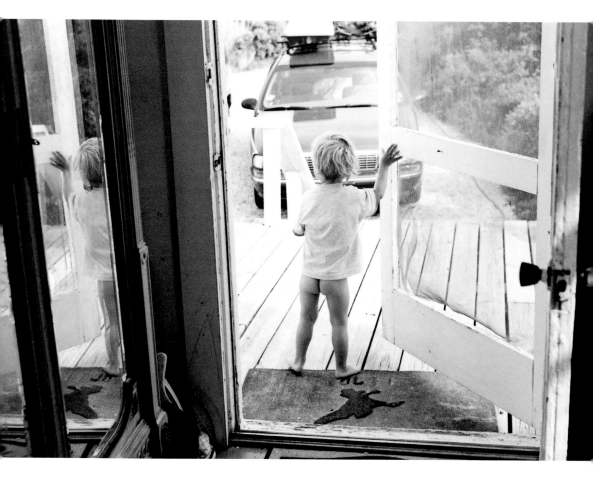

INDOORS

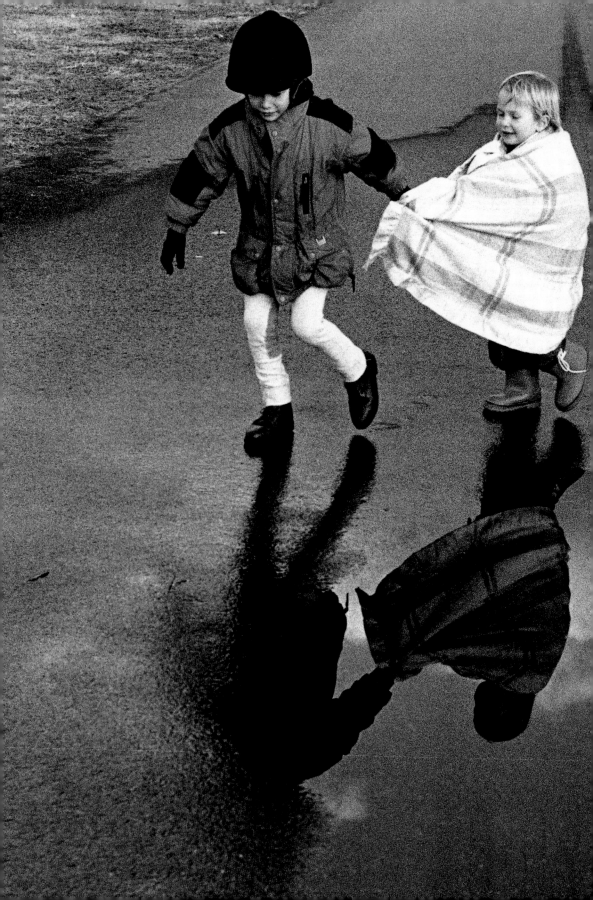

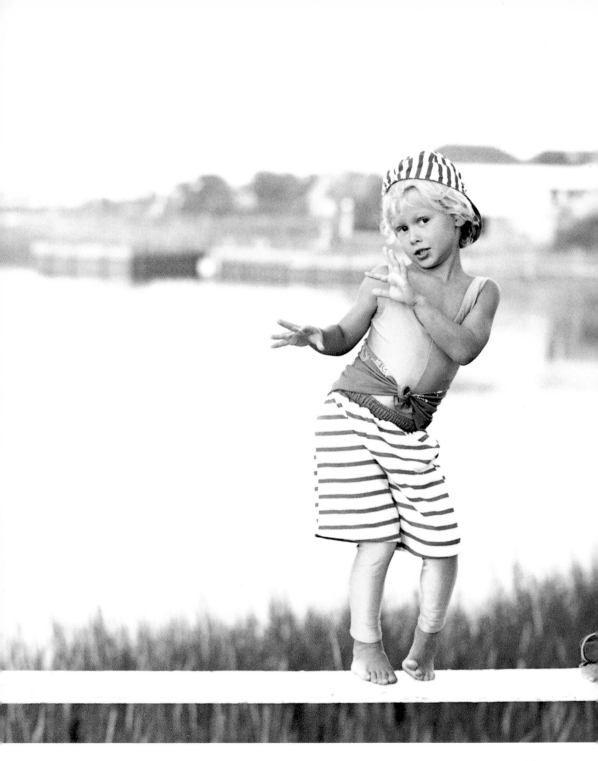

If it's a beautiful landscape — a pretty landscape and a very simple one to put them against — you should

always take a few shots of the whole scene. Meaning, walk away from everything, act like you're a tourist.

Take a memory shot and then come in. If you look carefully, there are fewer scenics than close-ups in this

book. I have to remind myself to do scenic pictures.

Now that I've edited my pictures, I've noticed, "Gosh, I could do a little more observation, it wouldn't

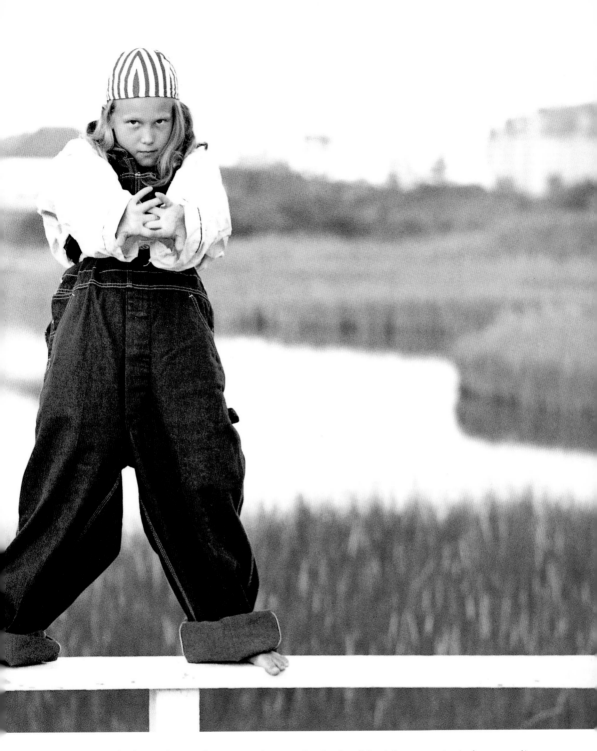

hurt." Or "Get back a little more because you love coming in close." I might even write it down on a list.

Don't forget to get back.

I'm so facial, that's the other thing I have to be more conscious of. What else did I say I was going to

do? Scenics, right.

Those are good. I recommend them. I just better do some myself.

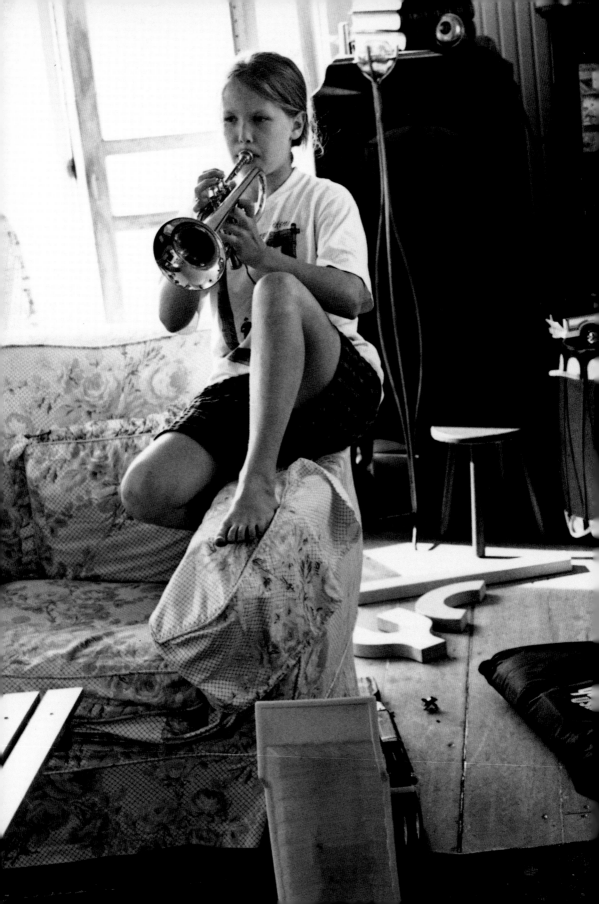

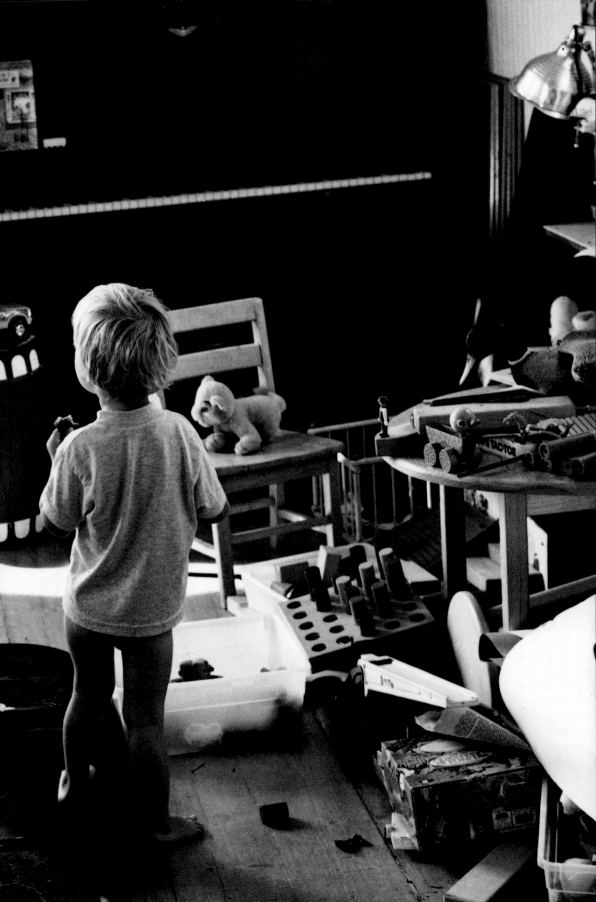

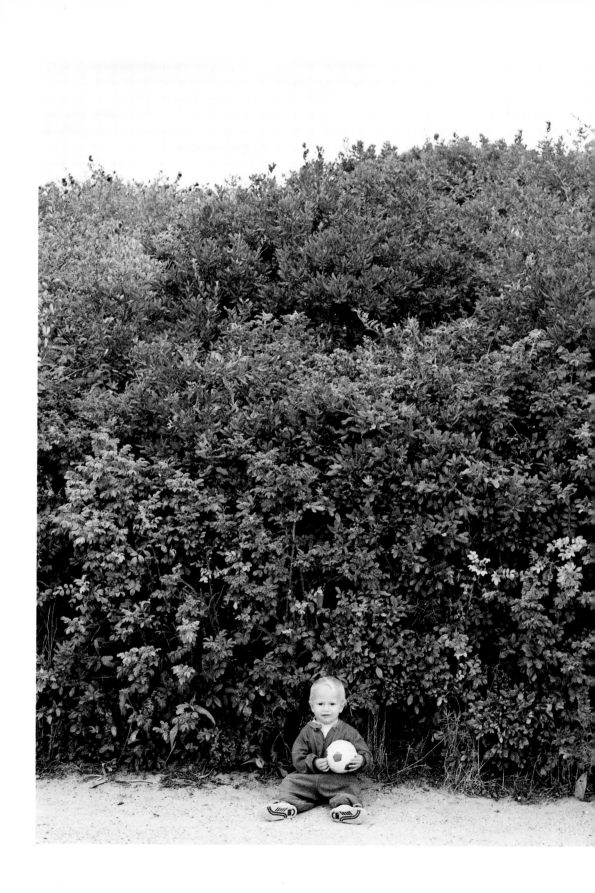

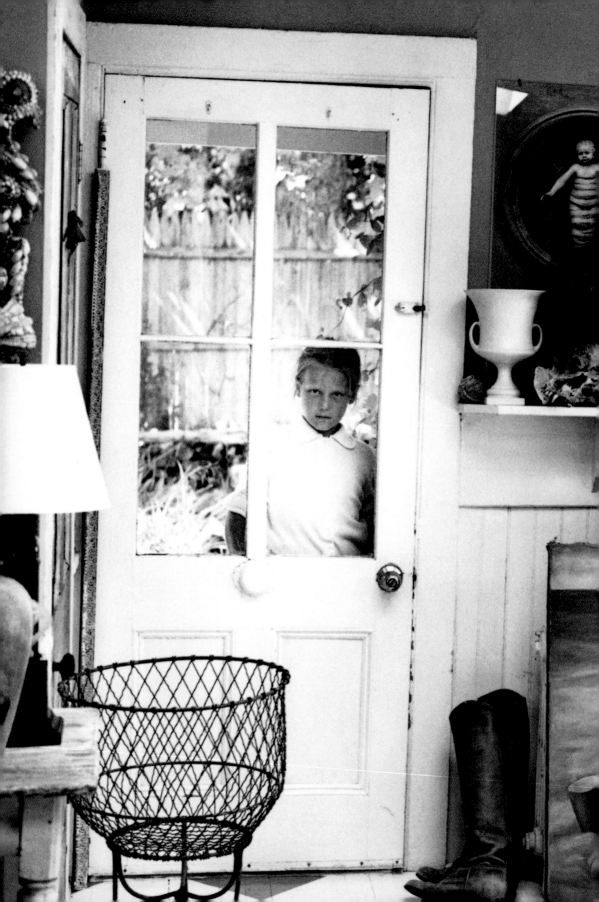

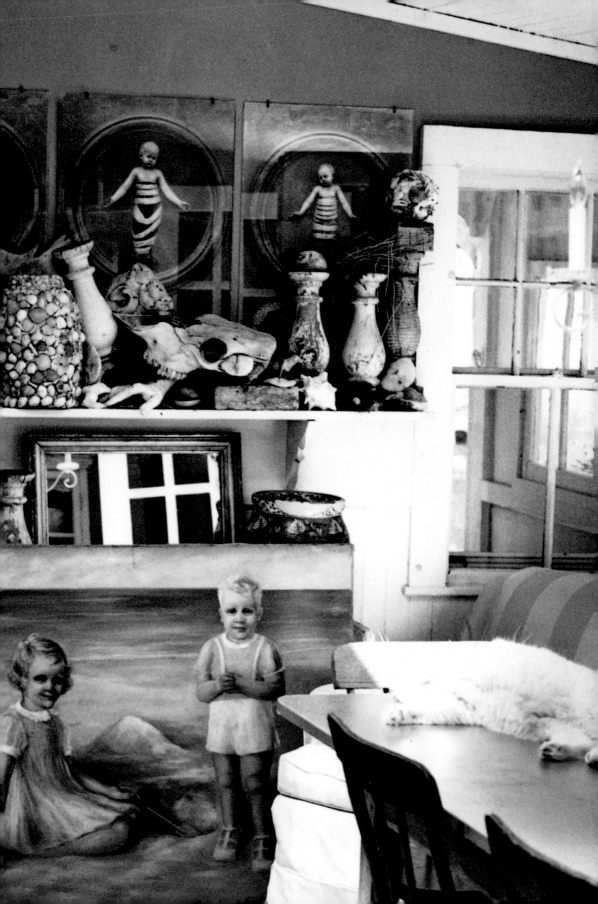

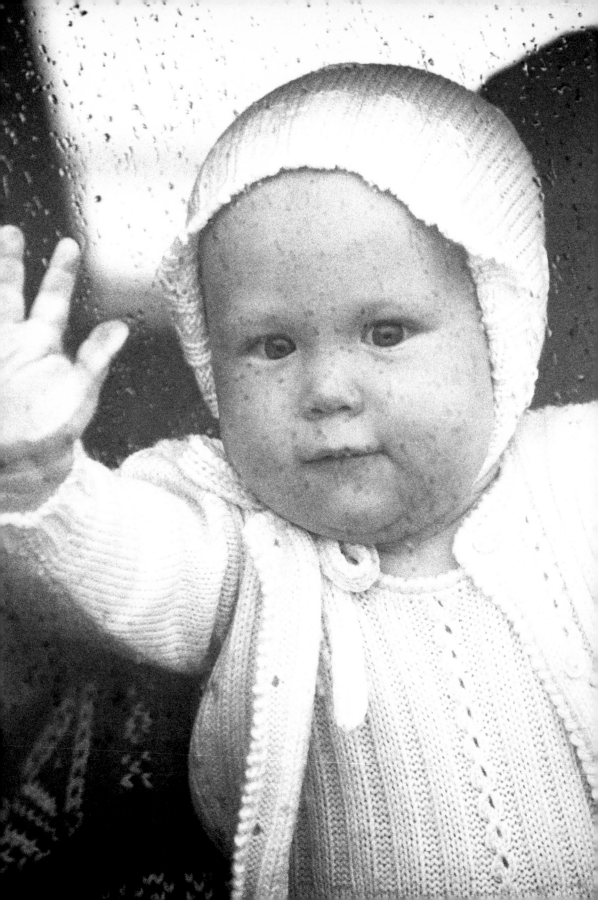

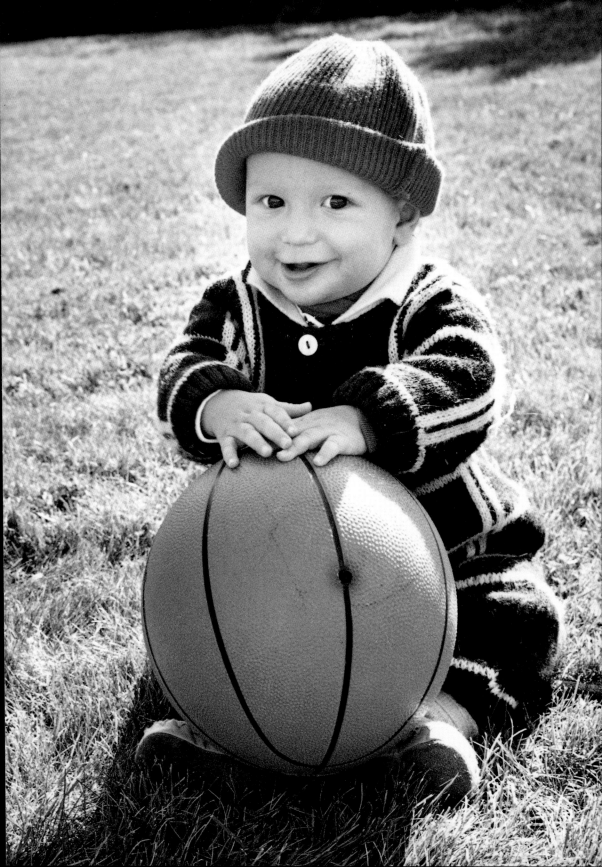

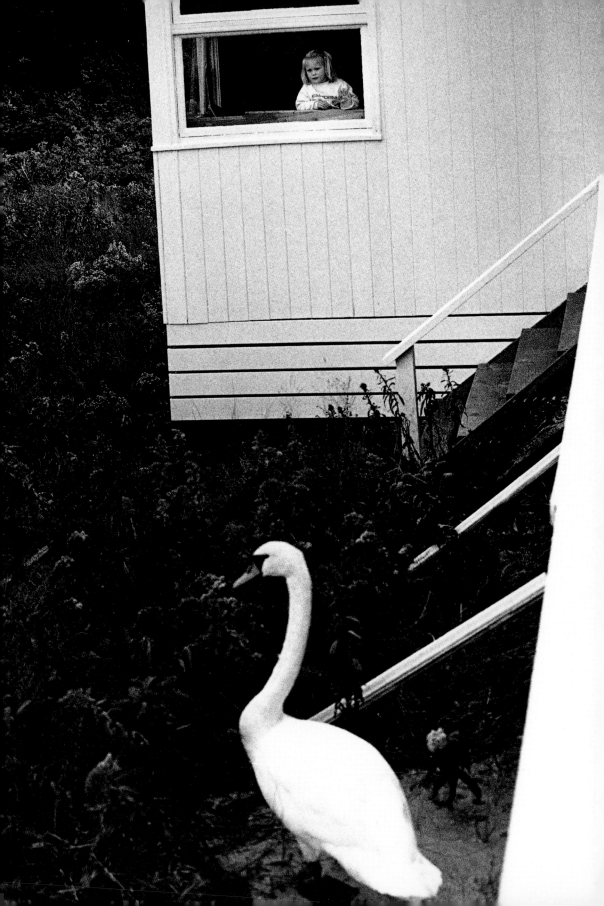

STRANGE

THINGS

HAPPEN

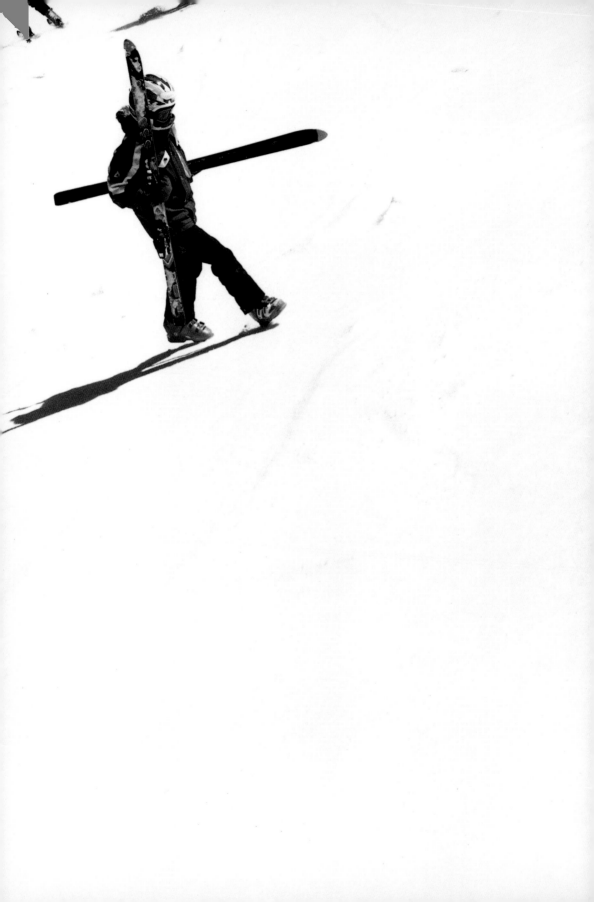

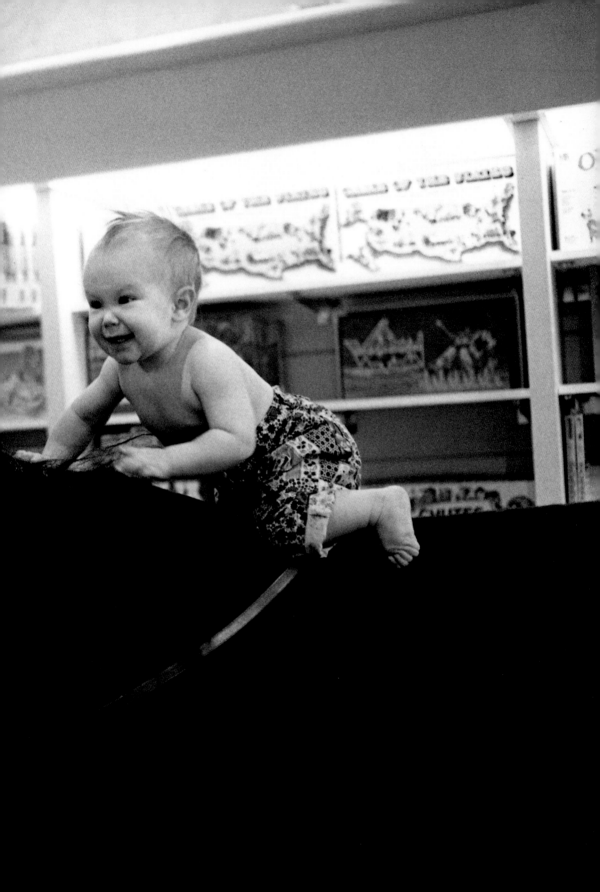

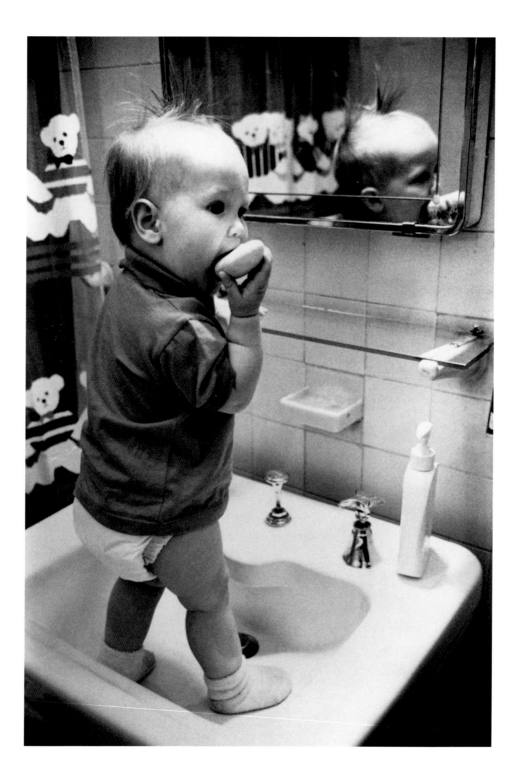

ABC's

You might just want pictures to put on the wall in the kitchen, on the fridge, whatever. You take a picture or two because you want that record. And once you play by a few simple ABC's, like keeping the camera near you, keeping it ready to take a picture and so on, then at almost any time you can lean over, get your camera, and get very good pictures of your kids. Especially if you are in the right place at the right time.

You don't have to buy the most expensive camera to take good pictures. "Oh my God, it's a Mercedes Benz!" That doesn't mean you're going to win the race. There are all these other things, like timing and reflexes. There's the heart and soul that go into it. And when your kids drop your Konica on the floor, you don't feel as bad as when they drop your Leica. Why is that?

You're finding a creative outlet. You're illustrating your stories about your kids. You're creating a wonderful history and everybody's a sucker for that: "Here's a picture of your father when he was twenty-one. Look at him when he was thin." Start now.

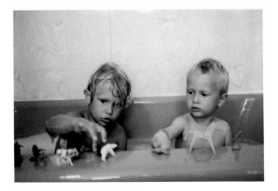

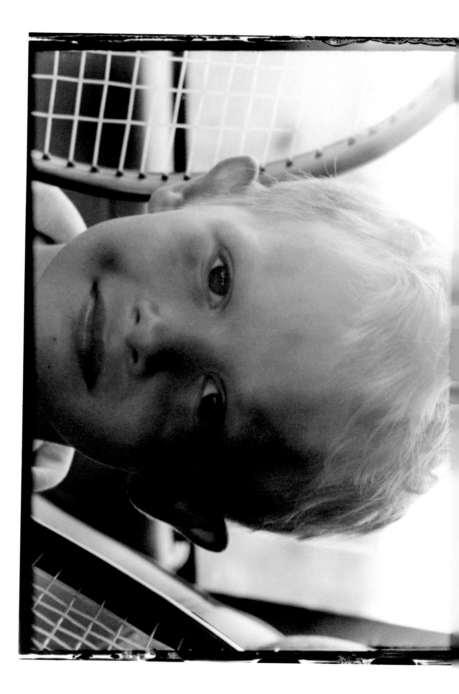

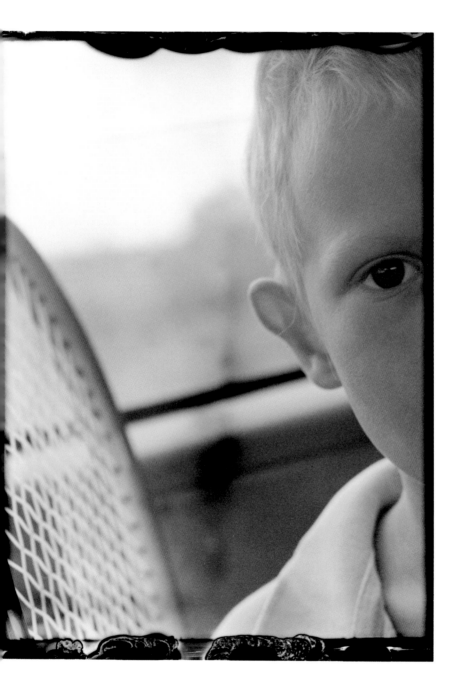

Experiment. Take chances.

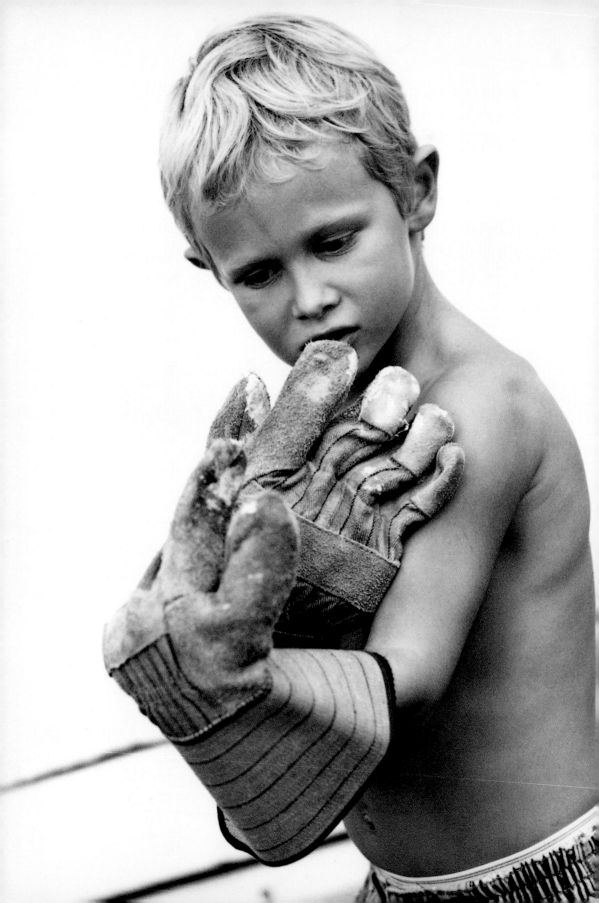

EQUIPMENT

What I call a fast, normal lens on a 35mm camera is usually 50mm, F2 to F1.4. Think of the lens as an eye. A normal lens is a faster lens, meaning that its eye is more open, so it is more sensitive to light. A 50mm lens is good in all kinds of light. It approximates the way you see. I like a fast normal lens, they're small and versatile. I take the majority of my pictures with that kind of lens. A zoom lens has a variable focal length, short 28 to 105mm, and long 70 to 200mm or even 300. They are fun to play with, they go in and out. Sports photographers use the long ones. They can make things far away closer, but they are slow, F4 or F5.6, which means they are less sensitive to light, and bulky. They are too slow for low light, better for outside pictures or flash! Long lenses are 200 to 600mm and very big and costly (and not exactly subtle). A telephoto lens is approximately twice the length of a normal lens, 85 to 105mm, somewhere between F2.8 and F1.4. It'll bring the subject closer to you and flatten it out a little. It's good for portraits or close-up faces. With a wide-angle lens, 21 to 35mm, you can get the whole party in the picture, but you also get some distortion.

35mm cameras I really like are the Olympus OMs, Nikon FE, Konica T4, Canon AE, Pentax MX and the Contax 137 — all with a normal lens. All of these are relatively small, light and quiet. And it's easy to press the shutter button and rewind lever quickly. I love Leica cameras, but they are very expensive. These cameras are all manual focus, but easy to use. A couple of good autofocus cameras are the Canon Elan II and the Pentax ZX5 — but make sure you start with a fast, normal lens! If you're starting with a point-and-shoot, a good one is the Canon Z135 or the Contax T series. But remember, all these cameras are generic. It's like a Ford Explorer and a Chevy Blazer. The ashtray's in a different place, but they're more or less the same. All the big companies make a good point-and-shoot now, but, in general, the point-and-shoots have slower lenses.

If you decide to buy a used or vintage camera, bring a friend who knows the territory. It's like buying a car: your friend could tell you, "There's only one problem: the shutter doesn't work and it will cost three hundred dollars to have it fixed."

Of the 2 1/4 cameras, I use the Rolleiflex, the Rolls Royce of cameras. It's quiet and has a timeless design. If you maintain it, it could live forever. But the others will do fine. Rolleiflex, Leica, and Nikon F are completely mechanical cameras: they have no batteries. They're like watches you wind up. You can always depend on them starting. Even for freezing-cold snow pictures.

A good, small flash is a Vivitar. It should recharge very quickly, so you can take another flash picture without waiting.

Good Film

for color,

try Kodak:

Kodacolor Gold 100/200/400

for black and white:

Ilford XP2

Kodak T-400CN

Tri-X

ASA NUMBERS:

100 — smoother, slower and sharper

200 — in-between

400 — more light sensitive, but grainier

(all of these

can be run out

at your neighborhood

photo processor — the supermarket,

the drug store, the one-hour

photo or the camera store.

remember to get a double

set of prints

for family and

friends.)

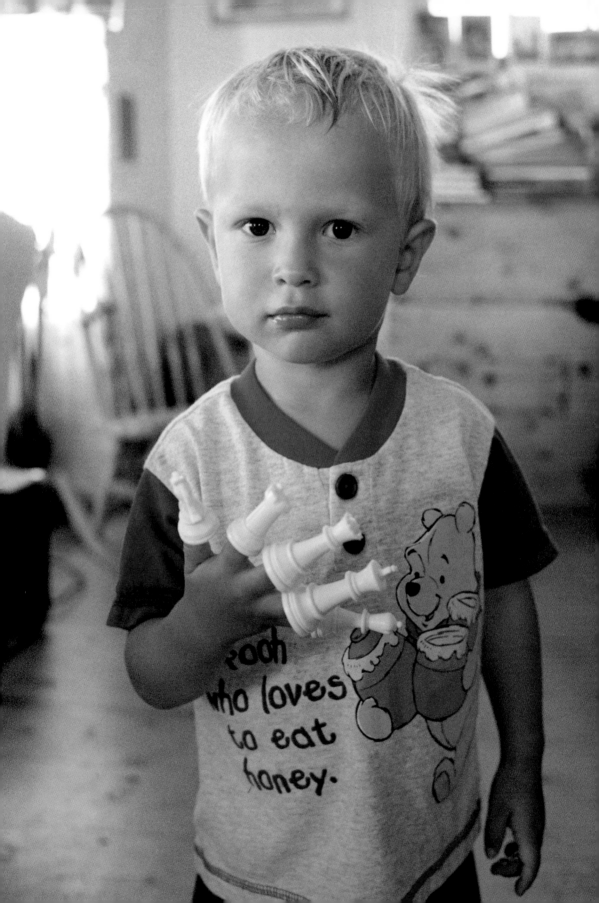

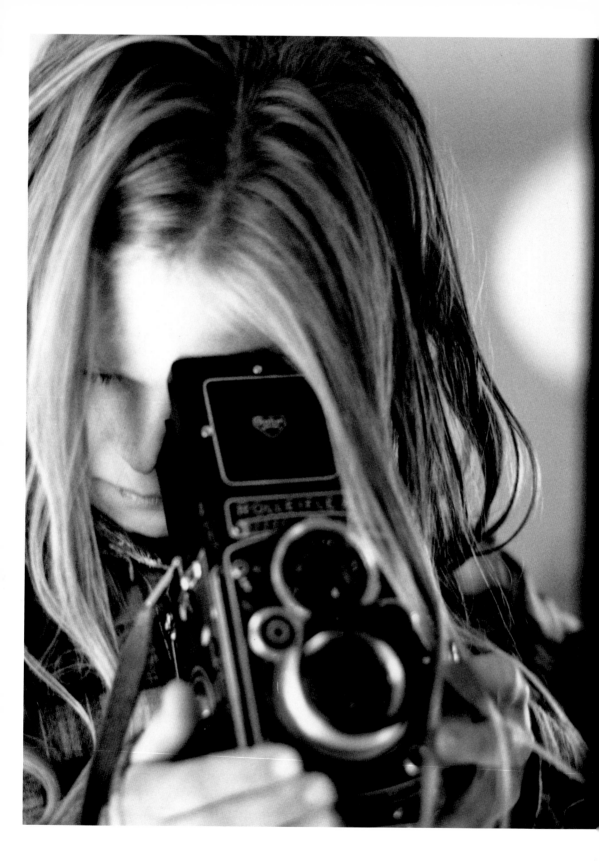

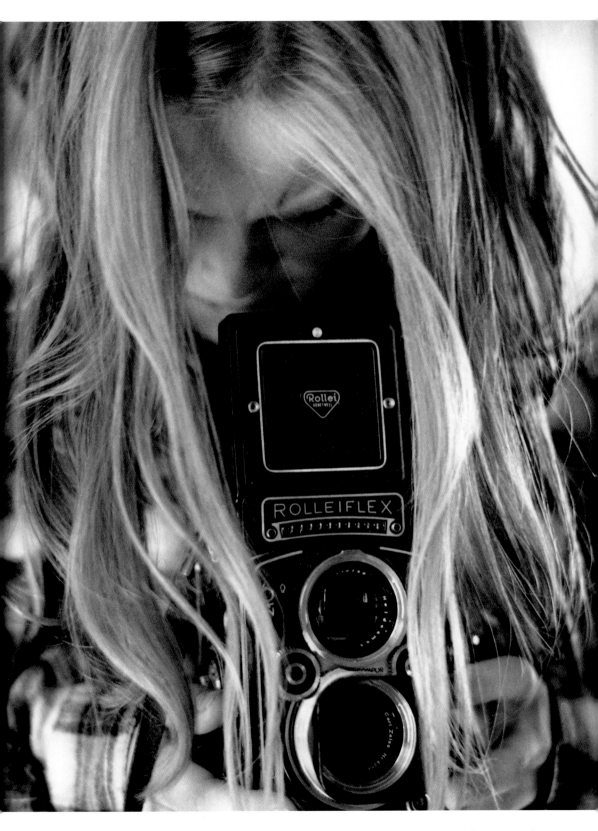

"Dad, can I do one of you?" Let them take a picture. They might get a good one.

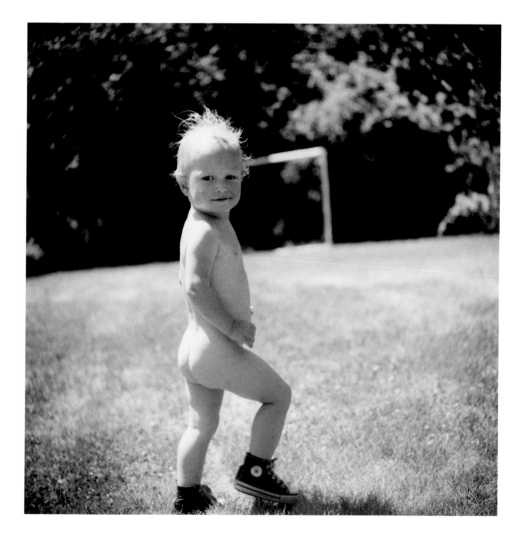

GOING TO 2 1/4

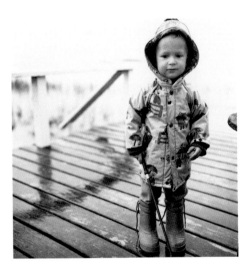

A waist-level camera is useful because you look at the picture and the camera is child-level, and your face is not covered. In the 2 1/4 square category, there are Rolleiflexes, but also the Yaschica Mat and Minolta Autocords, little box cameras that take 2 1/4 inch square negatives. And there are Seagull cameras made in China. They're a little flimsy, but they do the trick. Because, in China, for years, the two big reliefs the Communist party gave out were cameras and cigarettes for everybody.

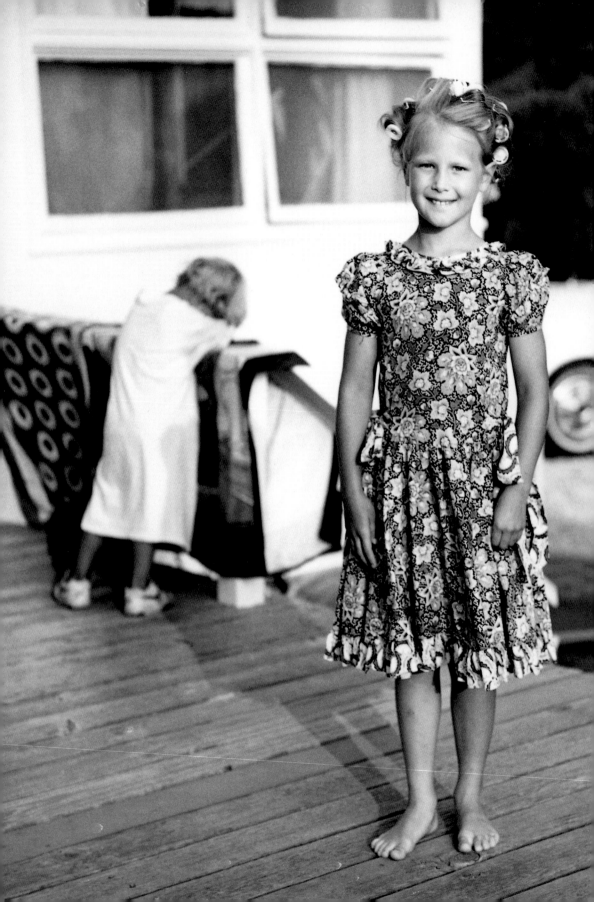

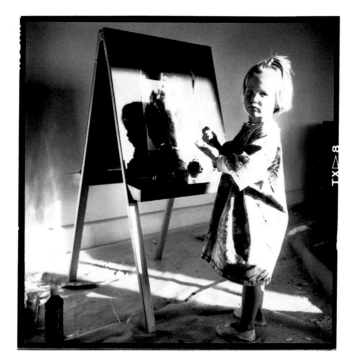

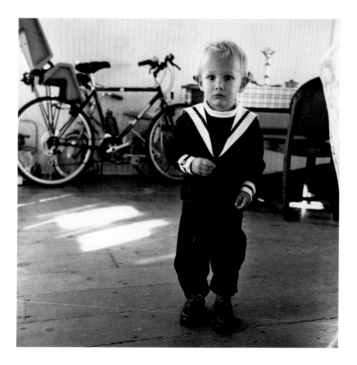

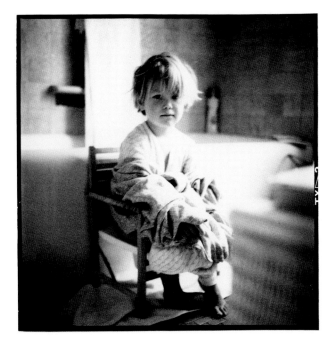

I like to take pictures that are timeless. Make the portraits,

you know, idealize them a bit. Like, "Girl on the Potty."

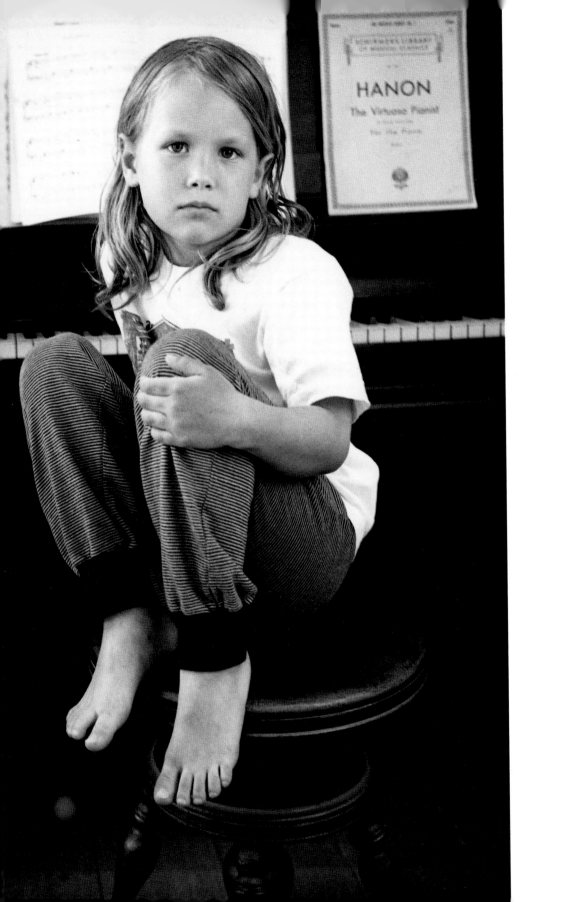

YOU HAVE TO MAKE A CHOICE

When it comes down to it, you get 36 chances. Or, when you shoot 2 1/4, you get 12. It's all the exact same amount of square footage. If you make contacts of your negatives, you have to make choices.

My advice is to look at them, make tentative choices and put them away. Then choose again. Live with it for a while. I put dots on them so I can remember what I decided. This is where grease pencils and magnifying glasses come in handy. And, on a rainy day, pull them out again and decide which pictures are "lasting." Then make a 5" x 7". Make three so you can send them to the grandparents.

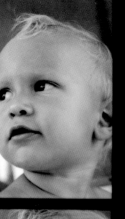
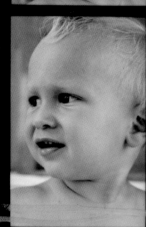
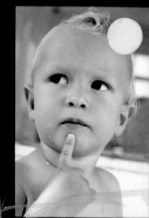

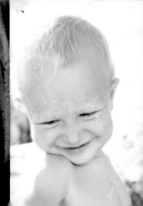

ILFORD XP2

ILFORD XP2

ILFORD XP2

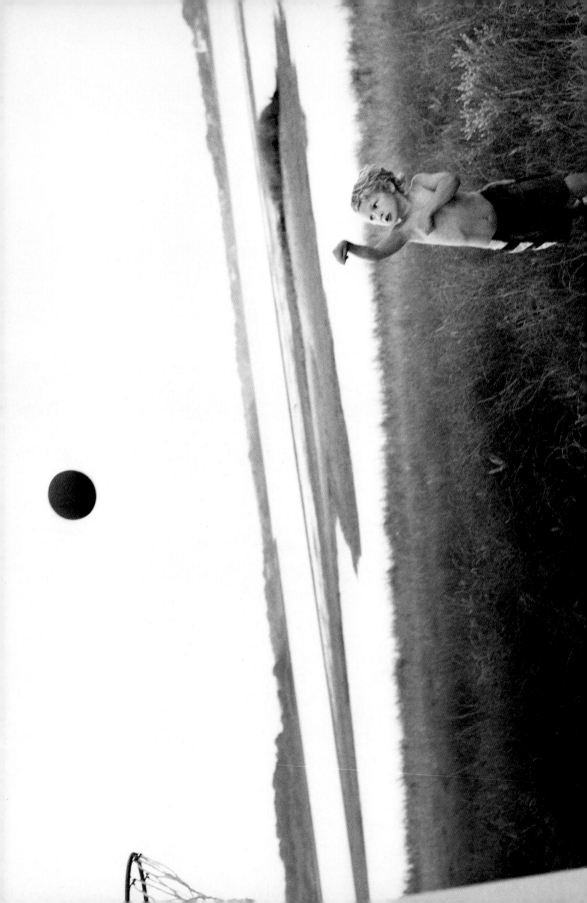

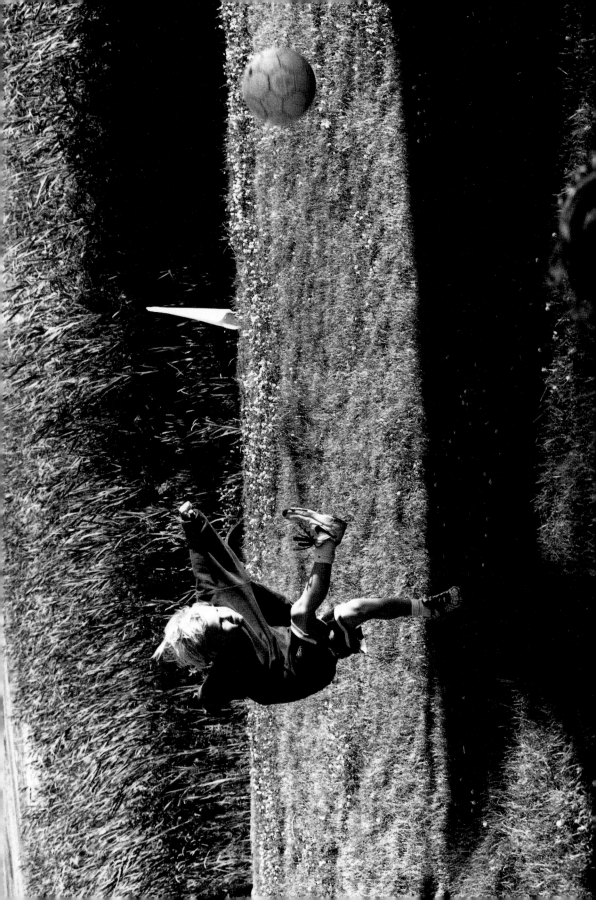

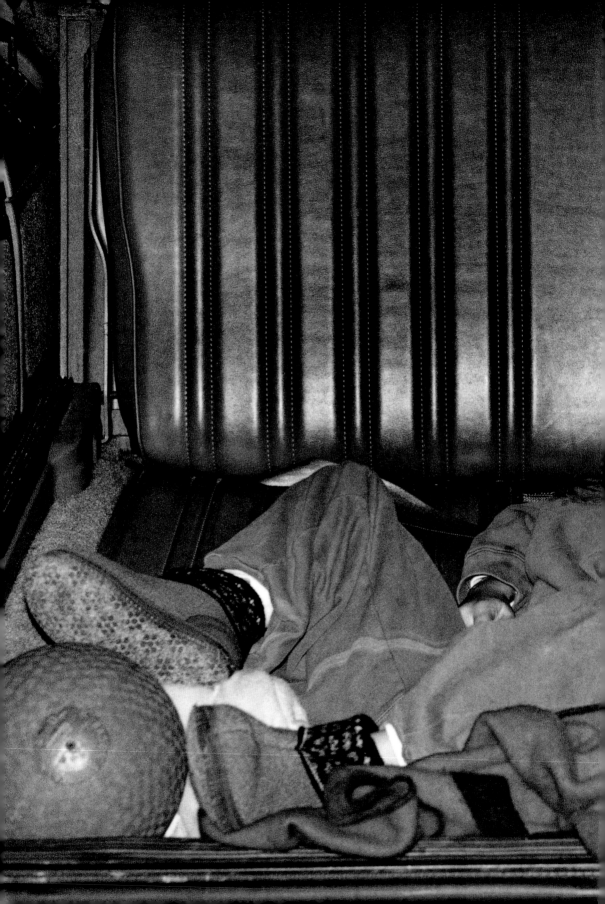

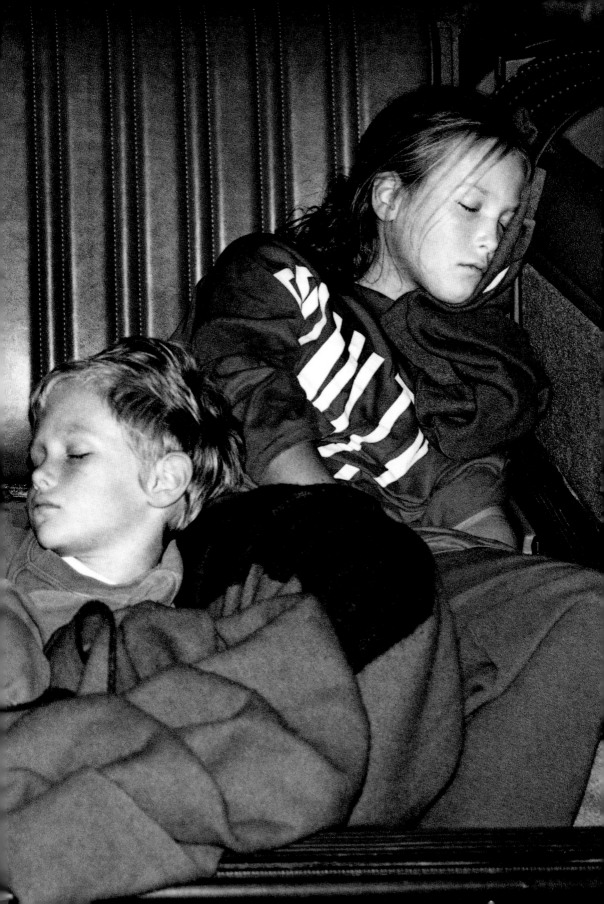

Hang this in your bathroom

always remember:

to keep your camera nearby

to put film in your camera

to rewind your film

to take off the lens cap

to preset your camera

to relax

to be ready

not to force it

to have fun

to practice

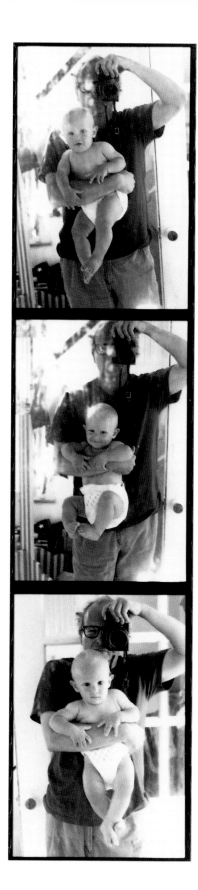

The Mirror

practice

in the

mirror

if your kid's not

cooperating, try

taking one

together

in the

mirror.

it is

a

good way

to make

a

self-portrait.

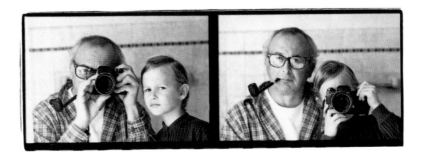

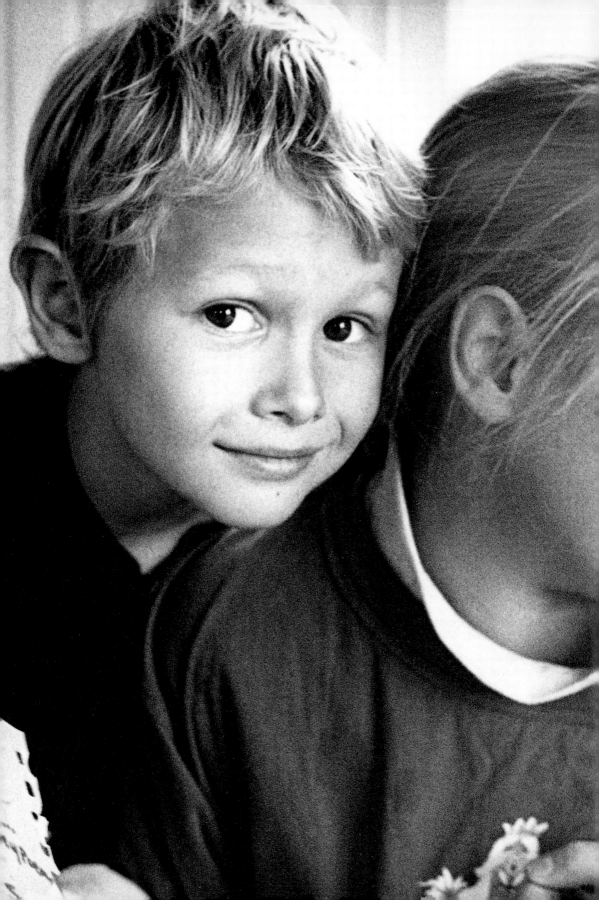

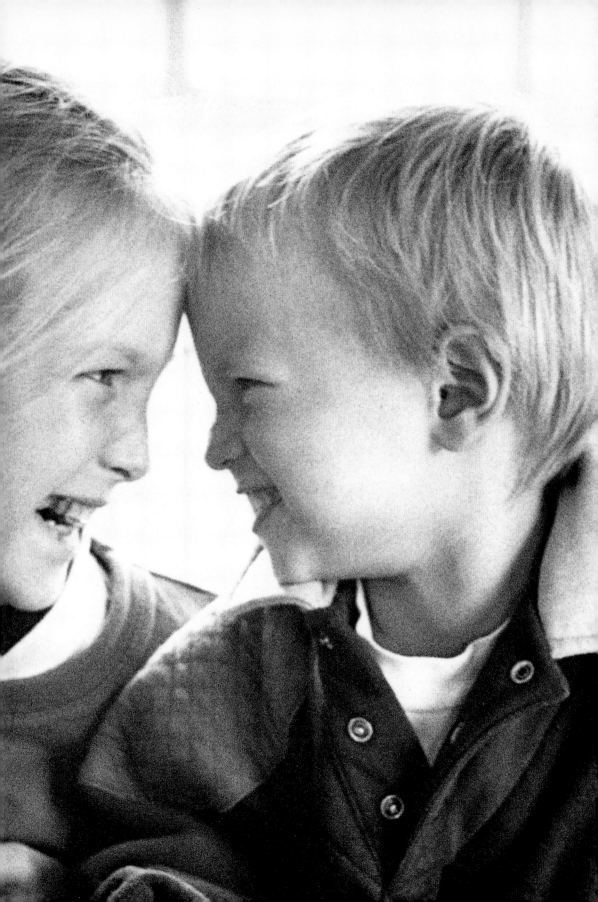

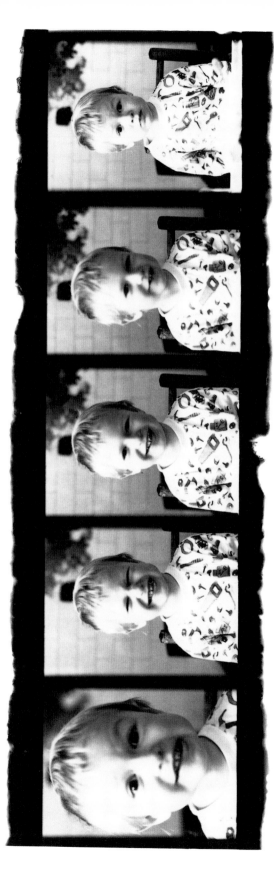

ART DIRECTION

Steve Hiett

DESIGN

Steve Hiett with Loseff Rodger Grey NY

EDITED BY

Marianne

TEXT BY

Ameena Meer

B&W PRINTS BY

Daphne K. Youree

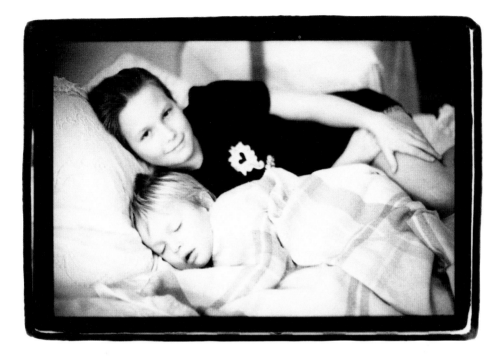

Photographs © 1997 Arthur Elgort.

Published in the United States by Grand Street Press.

Library of Congress Catalog Card Number: 97 - 61186

Distributed by Universe Publishing, a division of Rizzoli International Publications, Inc.
300 Park Avenue South, New York, NY 10010

Available to the U.S. trade through St. Martin's Press, New York,
and in Canada by McClelland & Stewart.

Printed in Italy.

2 MORE

ROLLS !

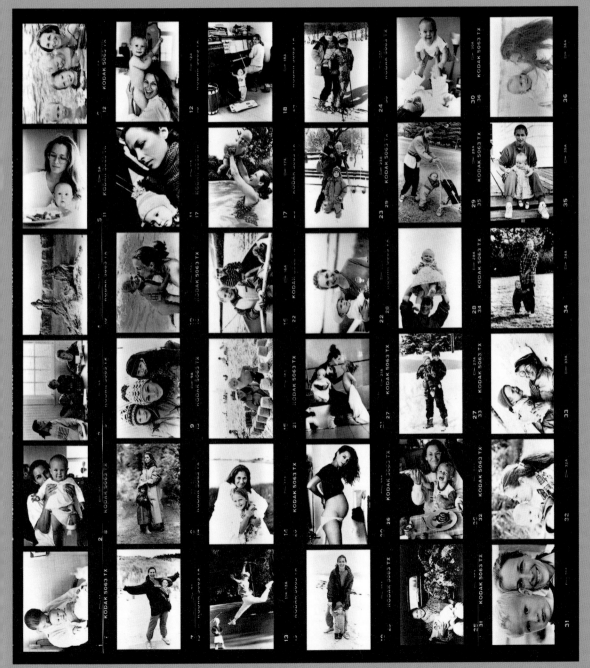

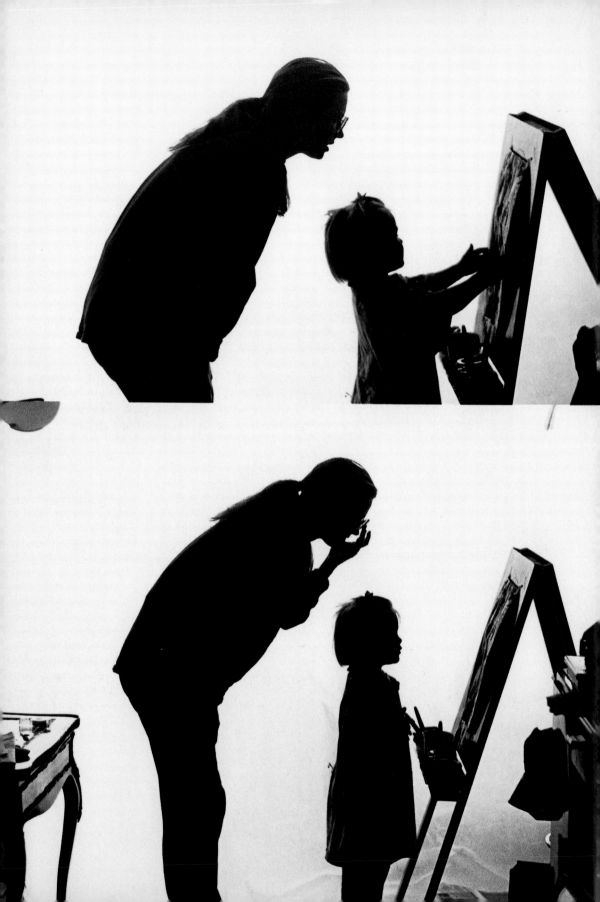

Mom is the star

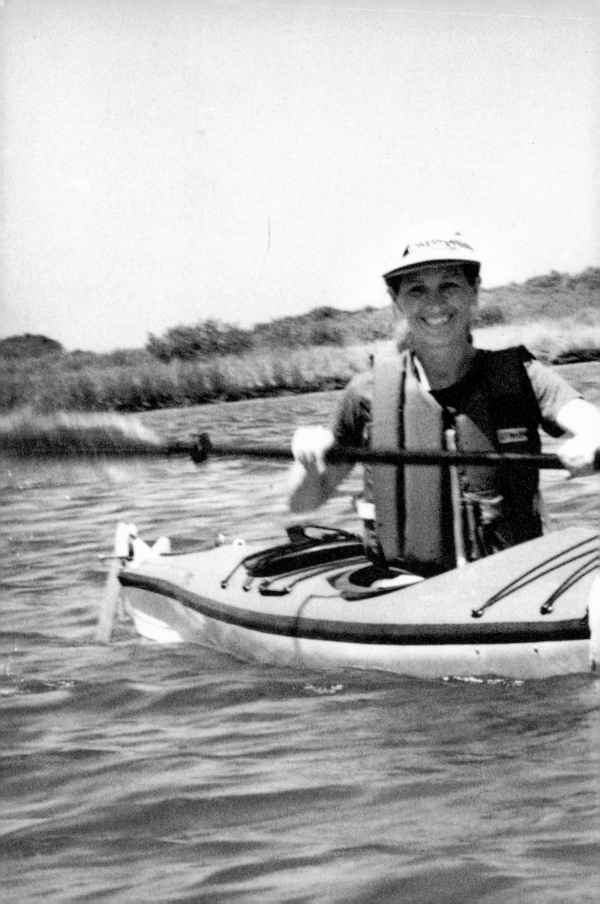